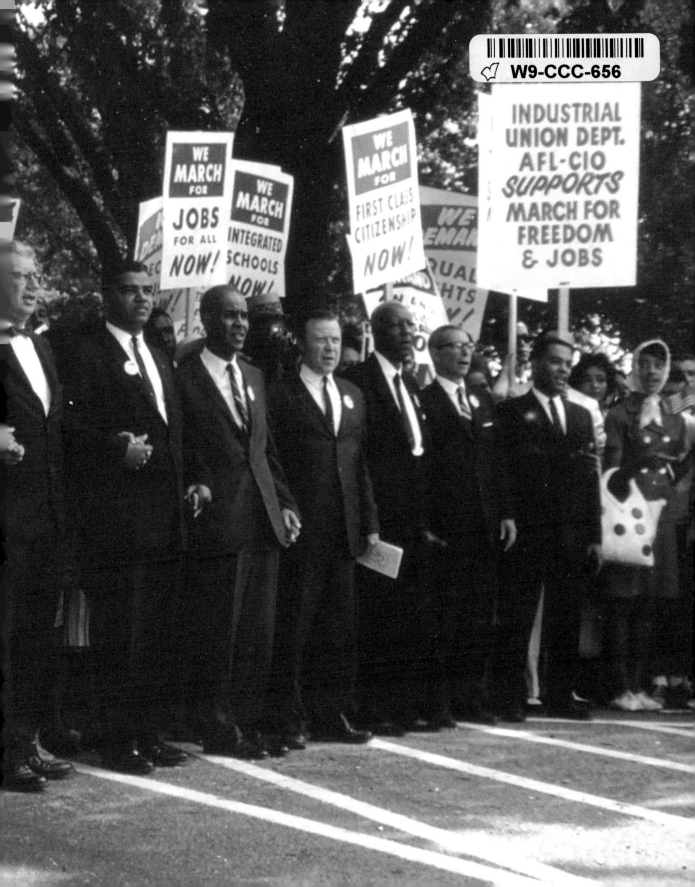

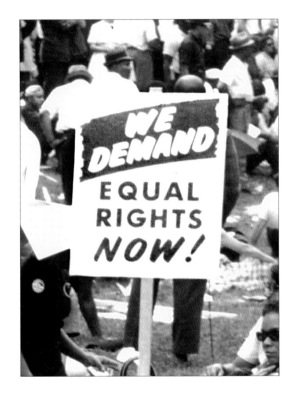

LET FREEDOM RING

◆　　◆　　◆

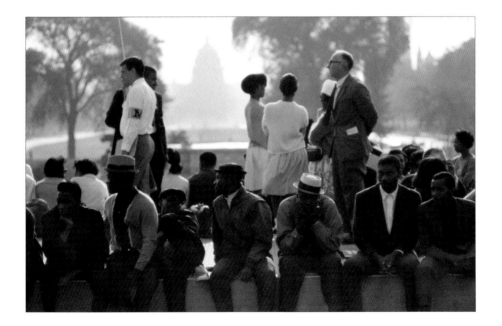

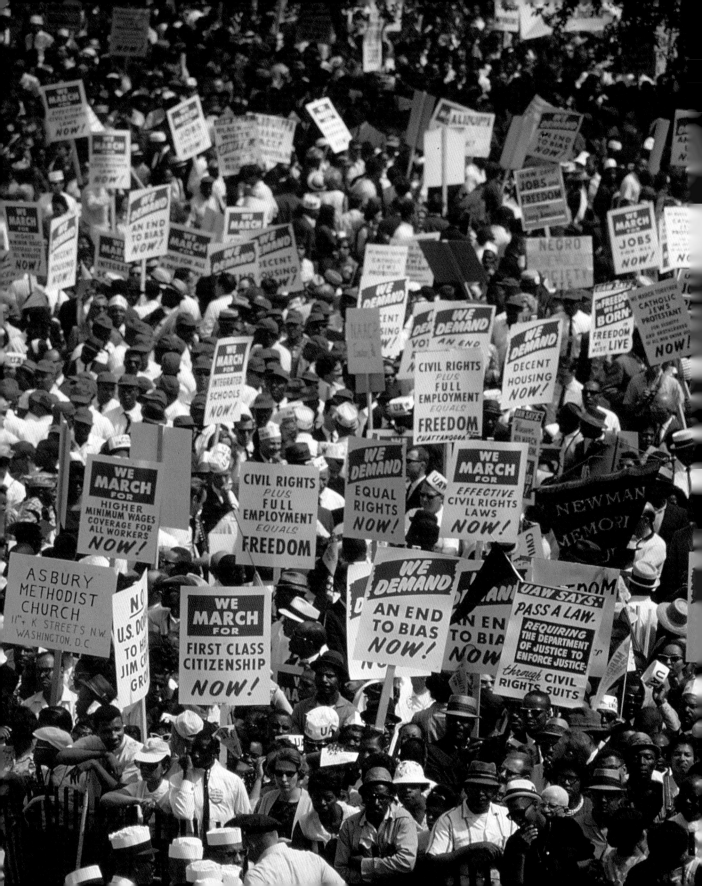

LET FREEDOM RING

Stanley Tretick's Iconic Images of
the March on Washington

◆ ◆ ◆

KITTY KELLEY

A THOMAS DUNNE BOOK · ST. MARTIN'S PRESS

Limited edition prints of all the photographs in *Let Freedom Ring*
can be ordered at www.StanleyTretick.com.

THOMAS DUNNE BOOKS.
An imprint of St. Martin's Press.

Interior Design: *Headcase Design*
Art Director: *James Sinclair*
Production Manager: *Adriana Coada*
Production Editor: *Eric C. Meyer*

ISBN 978-1-250-02146-5 (hardcover) · ISBN 978-1-250-02283-7 (e-book)

St. Martin's Press books may be purchased for educational, business, or promotional use.
For information on bulk purchases, please contact Macmillan Corporate and Premium Sales
Department at 1-800-221-7945 extension 5442 or write specialmarkets@macmillan.com.

First Edition: August 2013

10 9 8 7 6 5 4 3 2 1

TO ALL THE CHILDREN WHO NEED WINGS...

Rosa sat so Martin could walk,
Martin walked so Obama could run,
Obama ran so our children could fly.

◆ ◆ ◆

All proceeds from the sale of
this book will go to the
CHILDREN'S DEFENSE FUND

I AM SO GRATEFUL FOR THIS
wonderful book by the gifted photographer Stanley Tretick, who also
was a generous personal friend. His photographs of my young children
give me pleasure every day, and his powerful images of the March on
Washington rekindle unforgettable memories of the most transcendent, nonviolent, interracial, intergenerational, and interfaith gathering at the Lincoln Memorial of Americans for freedom and justice in our history. The event's specific name, "The March on Washington for Jobs and Freedom," should beckon us together again to demand with urgency and persistence an end to morally obscene wealth and income inequality, massive joblessness and poverty and the hunger, homelessness, and hopelessness they spawn, which blight America's landscape today and dash the hopes and dreams and chances of millions of children to grow up safe, healthy, and educated. Our two-tier playing field for rich and poor belie our pretentions to be a fair nation.

There is nothing more empowering than hope, struggle, and service in community with others for a purpose worth living and dying for. I will never forget the exhilaration I felt two months out of law school as a young lawyer at the NAACP legal defense fund preparing to practice law in Mississippi, driving from New York City to Washington with civil rights friends Ella Baker, Bob Moses, and Jane Stembridge, in my brother's old Volkswagen Beetle to stay with my sister Olive. We joined the throngs of others holding hands, singing, crying during the inspiring speeches, and believing with all our hearts that the America envisioned in the Declaration of Independence could be realized with the tireless work of our hands and feet and voices and votes and faith. We refused to believe, like Dr. King, that the bank of justice in America is bankrupt and that there are insufficient funds in the great vaults of opportunity of this nation.

On this 50th anniversary of the March on Washington, it's time for the next transforming movement not just to celebrate our great racial and social progress but to cash the check of opportunity—education, jobs, food, shelter, and safety still denied to millions of children—that is every child's birthright.

I am deeply grateful for the talent and dedication of Kitty Kelley to this book and I hope *Let Freedom Ring* will inspire and reignite our collective will to struggle to make America's dream a reality for every child.

— MARIAN WRIGHT EDELMAN
President, *Children's Defense Fund*

STANLEY TRETICK, SHOWN IN THE top right-hand corner, camera in hand, photographed the March on Washington for *Look* magazine. Here he is watching Senate Minority Leader Everett Dirksen (R-Illinois) raise his hand. From left: Rabbi Joachim Prinz, Whitney Young, Martin Luther King, Jr., Walter Reuther, Dirksen, John Lewis, and Mathew Ahmann.

Tretick was one of the most accomplished photographers of his era, known particularly for his intimate pictures of President Kennedy and his family. The never-before-published photographs of the March on Washington in this book capture the spirit of hope that crushed segregation and pushed the civil rights movement forward during the 1960s.

What Tretick saw on that memorable day, August 28, 1963, illuminates the humanity of one of the most important events of the twentieth century. Martin Luther King, Jr., believed that once people heard the truth, their tendency to bend toward what is right would pave the way for goodness to prevail. Much the same could be said of Stanley Tretick's images, which, like the photographer himself, were authentic and uniquely human.

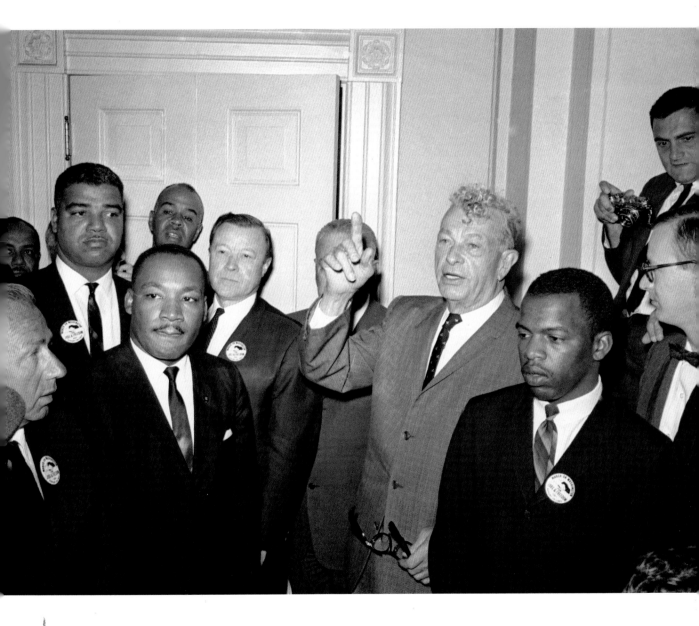

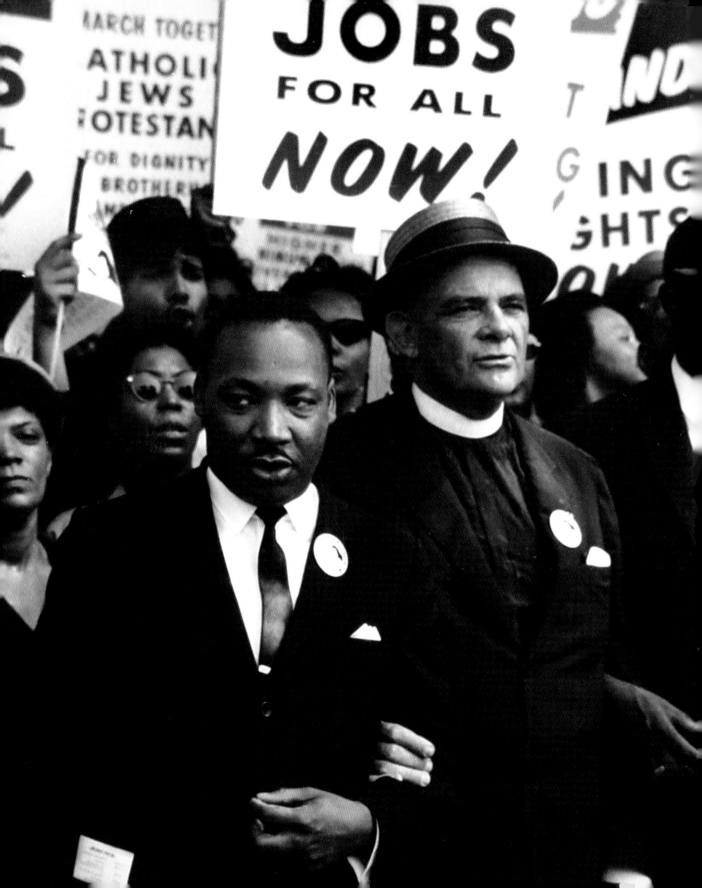

LET FREEDOM RING

◆　◆　◆

* * *

I T WAS A WEDNESDAY—
AUGUST 28, 1963 — BUT PEOPLE
STILL WORE THEIR SUNDAY BEST.

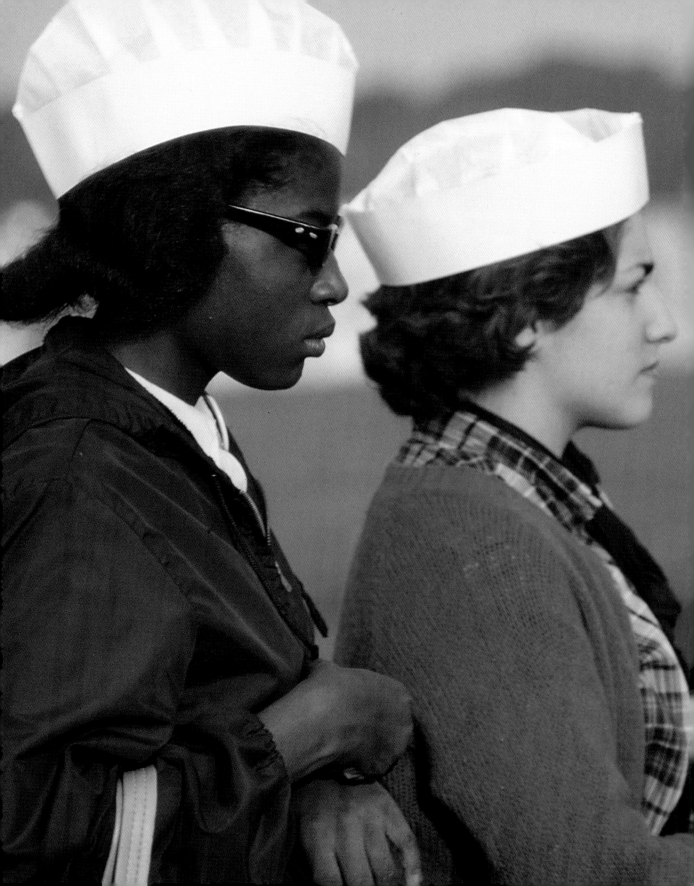

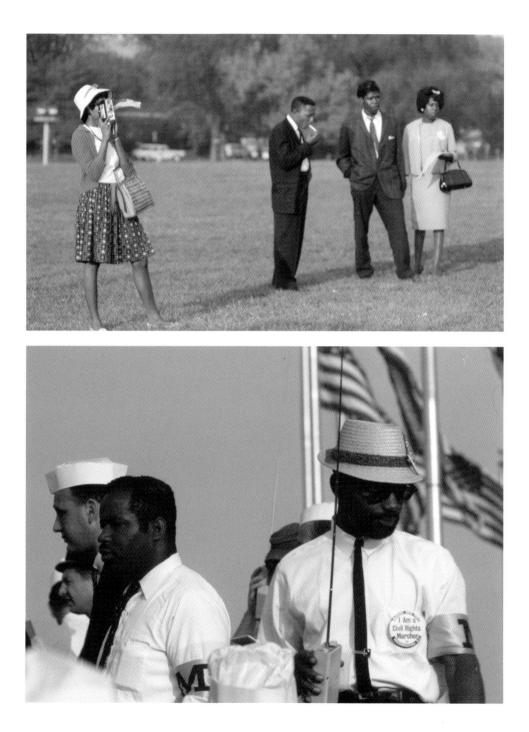

ESPITE THE HEAT AND humidity, they dressed for church: women donned hats and high heels; men in dark pants, white shirts, and ties fanned themselves with straw snap-brims. They came in droves, arriving by trains (37), chartered planes (11), blocks of buses (1,514), caravans of cars, and untold numbers of bicycles. One man even roller-skated from Chicago. In Washington, D.C.—soon to become known as "Chocolate City" to its majority black population—tens of thousands, young and old, stepped out of their front doors to head for the towering spire of the Washington Monument.

Stars such as Marlon Brando, Mel Ferrer, Susan Strasberg, James Garner, Bobby Darin, Robert Ryan, Dennis Hopper, Gregory Peck, Shelley Winters, Tony Bennett, Billy Eckstine, Rita Moreno, and Tony Franciosa arrived on chartered planes from California. Sammy Davis, Jr., flew in from Detroit, where he was performing in a nightclub. Paul Newman, Joanne Woodward, Charlton Heston, Diahann Carroll, Tony Curtis, Dolores Gray, Anne Jeffries, Lena Horne, Sidney Poitier, Ossie Davis, and Ruby Dee flew from New York. Burt Lancaster flew from Paris, where he was filming *The Train*. The dancer and jazz singer Josephine Baker flew from her home in Paris wearing her blue Free French uniform with five medals, showing she was a Knight of the Legion of Honor, an honor bestowed for her Resistance work during World War II.

Reverend Eugene Carson Blake *(left)*, of the National Council of Churches, shows his straw hat to Roy Wilkins, of the National Association for the Advancement of Colored People (NAACP). Both are wearing the official March buttons.

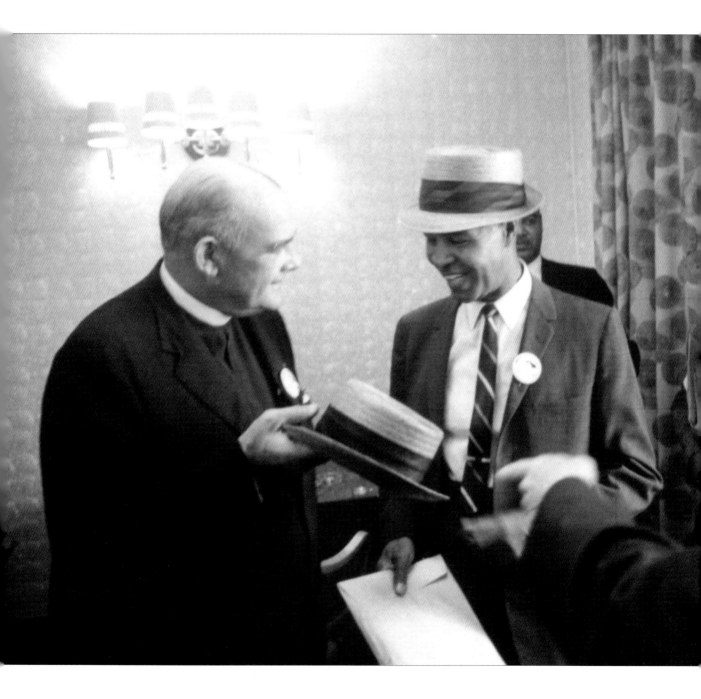

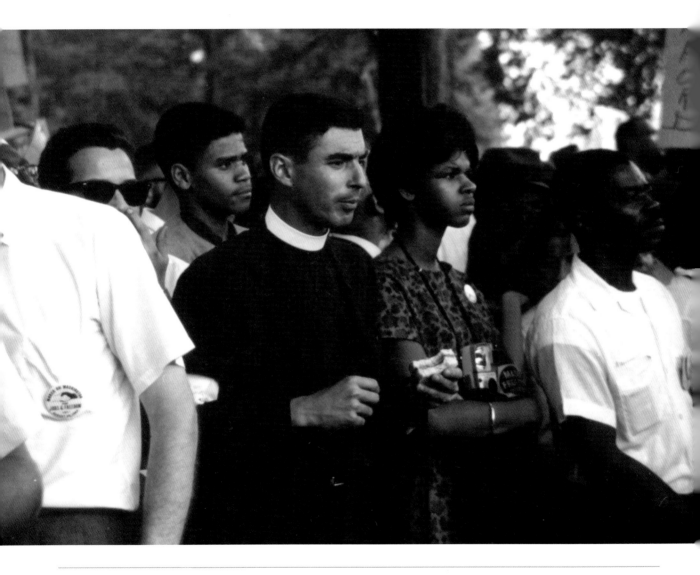

The marchers stood solemnly on the Mall for hours as they listened to each of the speakers on August 28, 1963.

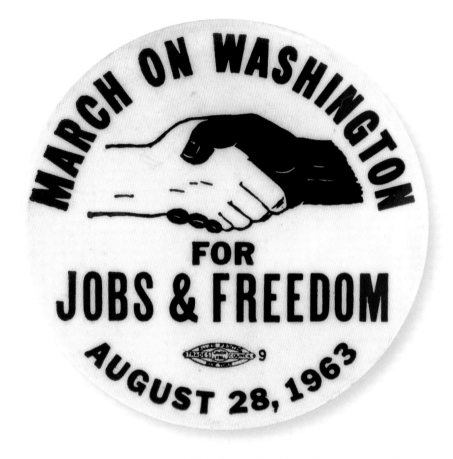

Many people wore big buttons featuring a strong black-and-white handshake to symbolize commitment to full employment for blacks. A. Philip Randolph explained: "We want a free, democratic society dedicated to the political, economic, and social advancement of man along moral lines." Martin Luther King, Jr., said: "One hundred years later the life of the Negro is still sadly crippled by the manacles of segregation and the chains of discrimination."

WE WILL MARCH BECAUSE WE recognize the events of the summer of 1963 as among the most significant we have lived through, and we wish to be a part of these events and of this time when promises made a century ago will finally be kept," said the statement of the Hollywood delegation.

All marchers, including the movie stars, were shuttled to the Washington Monument, and there strangers from Cleveland, Fayetteville, Greensboro, Harlem, Tulsa, Durham, Danville, Kansas City, and Little Rock mingled as friends. Some sang hymns as they walked side by side to the Reflecting Pool at the foot of the Lincoln Memorial.

All of them—blacks, whites, Jews, Catholics, Protestants, and Muslims—shared the same dream: freedom and equality for 19 million African Americans. They had come to Washington from across the country and around the world to bear witness—almost 300,000 strong—to petition Congress to pass the President's Civil Rights Act. Their March on Washington in the summer of 1963 was historic in size and style and substance. It was the largest assembly ever to gather at the marble feet of the Great Emancipator, and the gathering was as joyous as a jamboree.

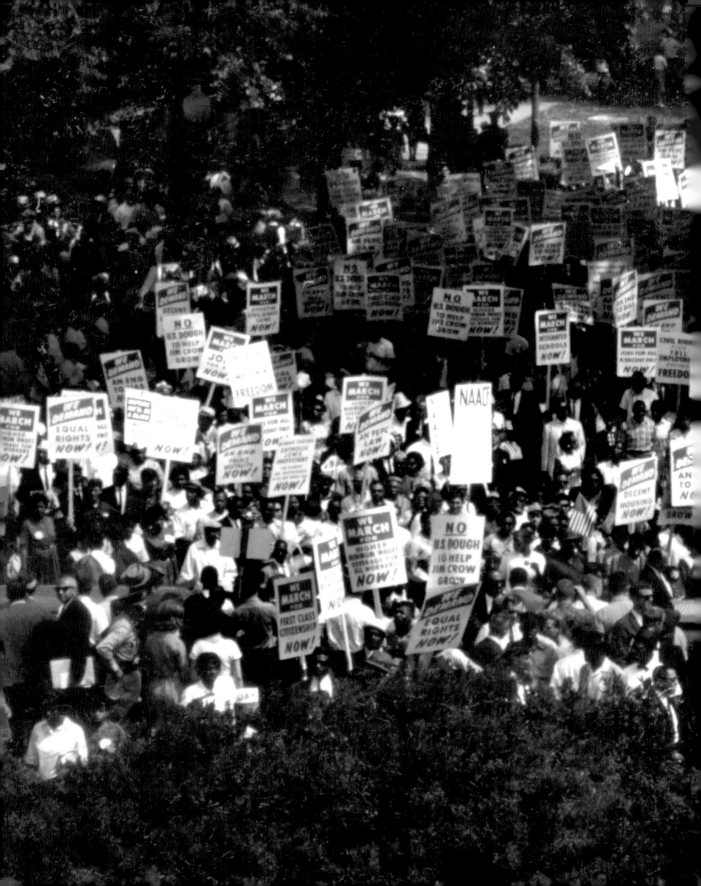

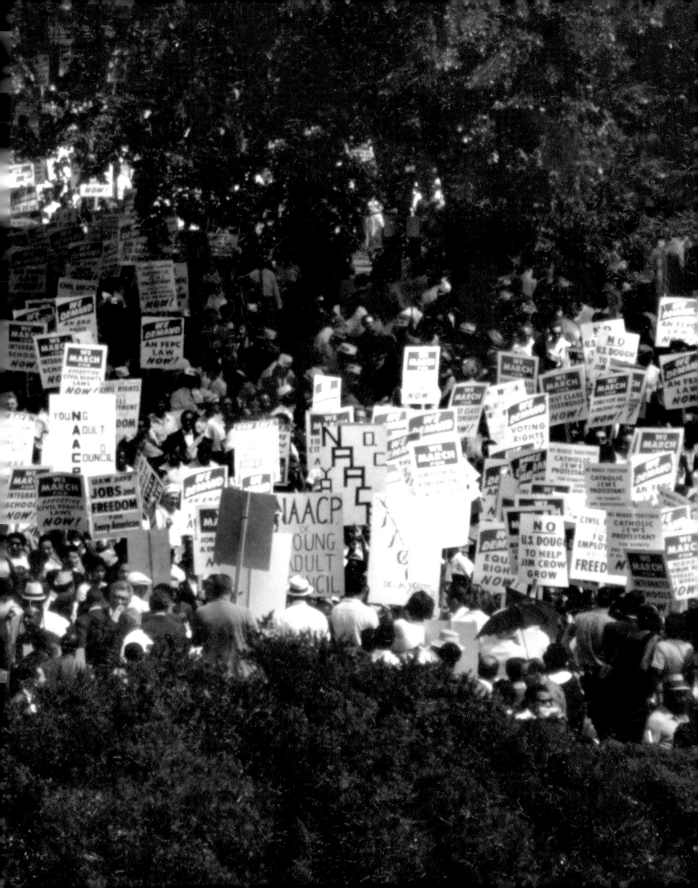

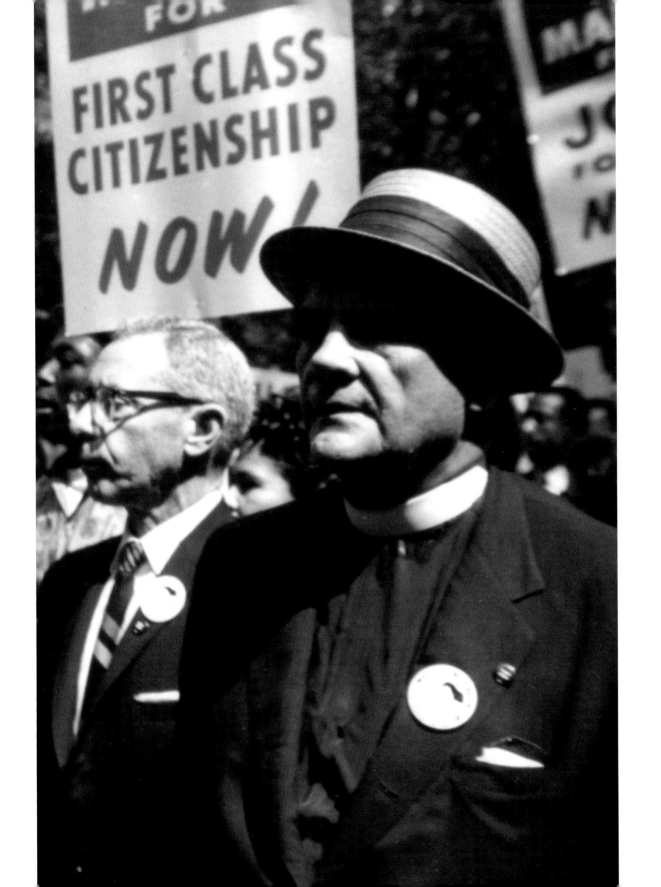

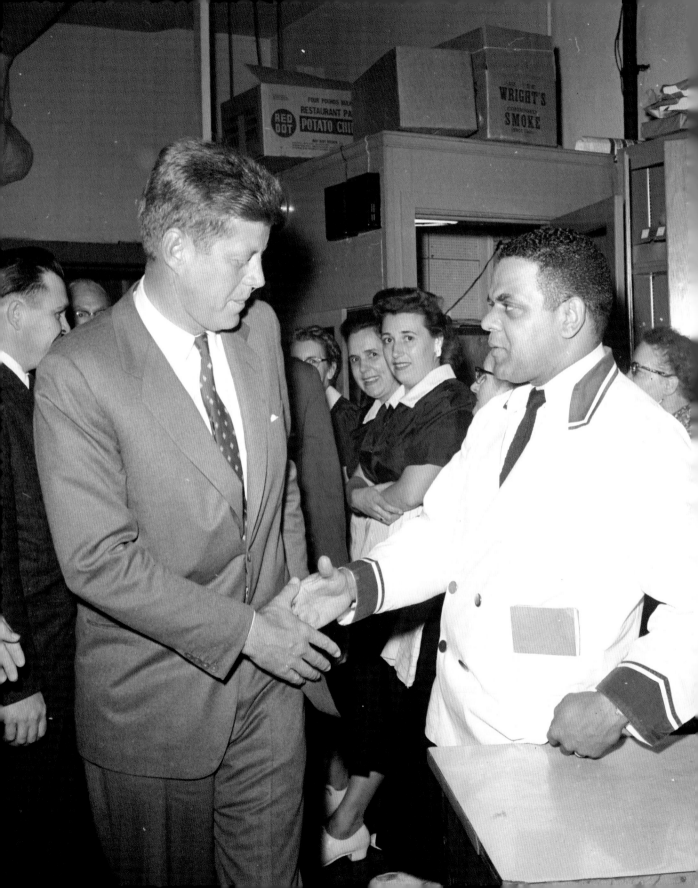

Those who shared the dream wanted to come to Washington on August 28 to show Congress that they would no longer tolerate isolating the "Negro," as Dr. King would say in his speech that day, to "a lonely island of poverty...an exile in his own land." They wanted to march on Washington to compel Congress to pass comprehensive legislation that would do away with segregated public accommodations; protect the right to vote; redress violations of constitutional rights; desegregate all public schools; develop a massive federal works program to train and place unemployed workers; and pass a federal Fair Employment Practices act that would bar discrimination in all employment.

They had been sickened by the sight of Eugene "Bull" Connor's police force clubbing freedom marchers in Birmingham, Alabama, where so many black homes and churches and schools had been bombed that the city became known as "Bombingham." They recoiled in horror as Connor, the Commissioner of Public Safety, unleashed snarling dogs to attack peaceful protesters and directed his police force to use electric cattle prods for crowd control. On top of that, he ordered men, women, and children to be mowed down with fire hoses equipped with nozzles that could blow bricks from mortar a hundred feet away.

Watching the television coverage on May 3, 1963, President Kennedy said he was nauseated by the images of German shepherds digging their teeth into the flesh of protesters and little children sent skittering into buildings by the force of the fire hoses. "The shameful scenes in Birmingham are so much more eloquently reported by the news cameras than by any number of explanatory words," the President told an audience. He later jolted civil rights leaders when he met with them at the White House. "You shouldn't be so hard on Bull Connor," he said with irony. "He's done more for civil rights than anyone."

John F. Kennedy greets kitchen workers during the 1960 presidential campaign. JFK's support for equal rights gave him the overwhelming support of labor and the black community.

During the 1960 presidential campaign, John F. Kennedy had called Coretta Scott King when her husband was jailed in Georgia for a traffic violation. "I know this must be very hard for you," he said. "I understand you are expecting a baby and I just wanted you to know that I was thinking of you and Dr. King. If there is anything I can do to help, please feel free to call on me." It was a brief call with a big return. When Martin Luther King's father saw how pleased his daughter-in-law was, he said: "I was going to vote for Nixon because I'm a Baptist and Kennedy's a Catholic, and I was leading the Negro ministries in Atlanta in supporting Nixon. But now I'm here to deliver a suitcase full of votes because Senator Kennedy has called my daughter-in-law and wiped the tears from her eyes." Kennedy received 72 percent of the black vote in the 1960 election.

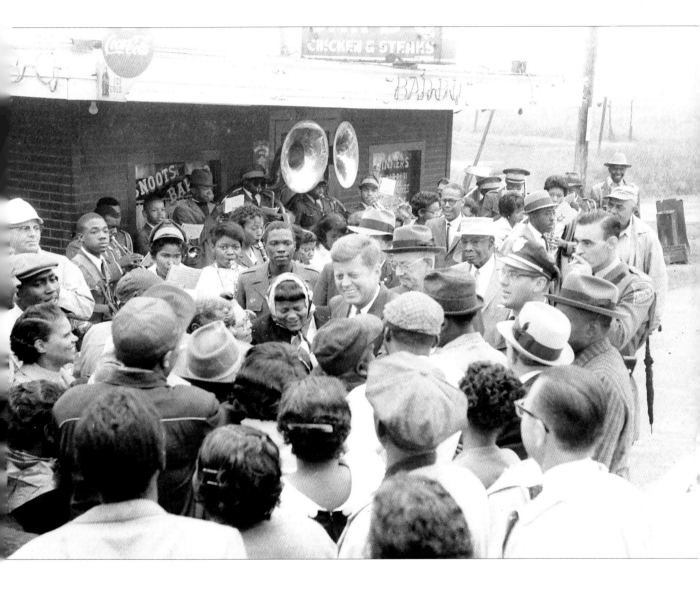

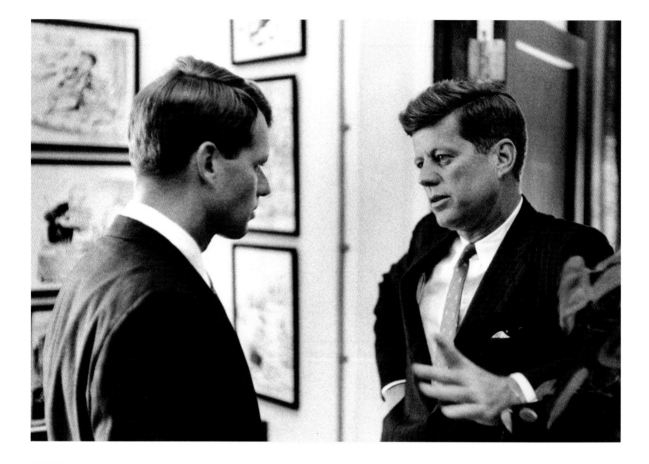

Attorney General Robert F. Kennedy reports to the President on the race riot at the University of Mississippi (Ole Miss), September 30, 1962, during which three were killed and at least fifty wounded when James Meredith tried to enroll. The Kennedys sent 300 U.S. marshals to escort Meredith onto the Oxford, Mississippi, campus, but mobs of segregationists attacked the marshals with guns, bricks, and Molotov cocktails. The President then sent in the National Guard to restore order. Meredith, the first black person to attend Ole Miss, finally registered, and graduated in 1963.

AS A CANDIDATE, JFK PROMISED to eliminate housing segregation with "a stroke of a pen," and as President he used his executive power to end discrimination in federally financed housing. His Justice Department petitioned the Interstate Commerce Commission to issue rules prohibiting segregated seating on buses, displays of "white" and "colored" signs in bus stations and train stations, and segregation at any and all station lunch counters. He ordered federal marshals to Alabama to protect the Freedom Riders in 1961, and again sent federal marshals to Oxford, Mississippi, in 1962 to protect James Meredith, who became the first black person to enter the state's all-white university.

But the President, afraid he might rile Dixiecrats (Southern segregationists), dragged his feet on proposing comprehensive civil rights legislation. Those who wanted him to stand tall on the issue of race felt he came up short. His was not a profile in courage, but of caution. To them he was a rich white man watching from the box seats—removed from the turmoil. The President, on the other hand, was a pragmatic politician, who knew he would not have won the White House in 1960 without the electoral votes from the South, and he did not want to jeopardize his chances for reelection in 1964.

Of all the civil rights activists, Roy Wilkins of the NAACP was probably the most sympathetic toward the restrained President. "I can understand a little even though I'm over here on the suffering side. I can understand that a man who has to look out for the welfare of fifty states might well feel that he cannot afford to take certain steps that will alienate twelve or fifteen states."

◆ ◆ ◆

Roy Wilkins (1901–1981) served as Executive Secretary
of the National Association for the Advancement of Colored
People from 1955 to 1977, when NAACP membership
reached 400,000.

Known as "Mr. Civil Rights," Wilkins was moderate in his
language and temperament, and lacked the charismatic style of
other leaders in the movement.

He met with every President from Franklin D. Roosevelt to
Jimmy Carter, and became a close personal friend of Lyndon B.
Johnson. During the mid-1960s Wilkins opposed the Black
Power movement and its calls for black segregation, saying:
"Black Power can mean in the end only black death."

◆ ◆ ◆

We came to speak here to our Congress, to those men and women who speak here for us in that marble forum over yonder on the hill.... We want employment and with it we want the pride and responsibility and self-respect that goes with equal access to jobs.

Now for nine years our parents and their children have been met with either a flat refusal or token action in school desegregation. Every added year of such treatment is a leg iron upon our men and women. The civil rights bill now under consideration in the Congress must give new powers to the Justice Department to enable it to speed the end of Jim Crow schools, South and North.

Now, my friends, all over this land, and especially in parts of the Deep South, we are beaten and kicked and maltreated and shot and killed by local and state law enforcement officers.

It is simply incomprehensible to us here today and to millions of others far from this spot that the United States government, which can regulate the contents of a pill, apparently is powerless to prevent the physical abuse of citizens within its own borders.

Now the President's...package needs strengthening, and the President should join us in fighting to be sure that we get something more than pap.... We expect passage of an effective civil rights bill.

◆　　◆　　◆

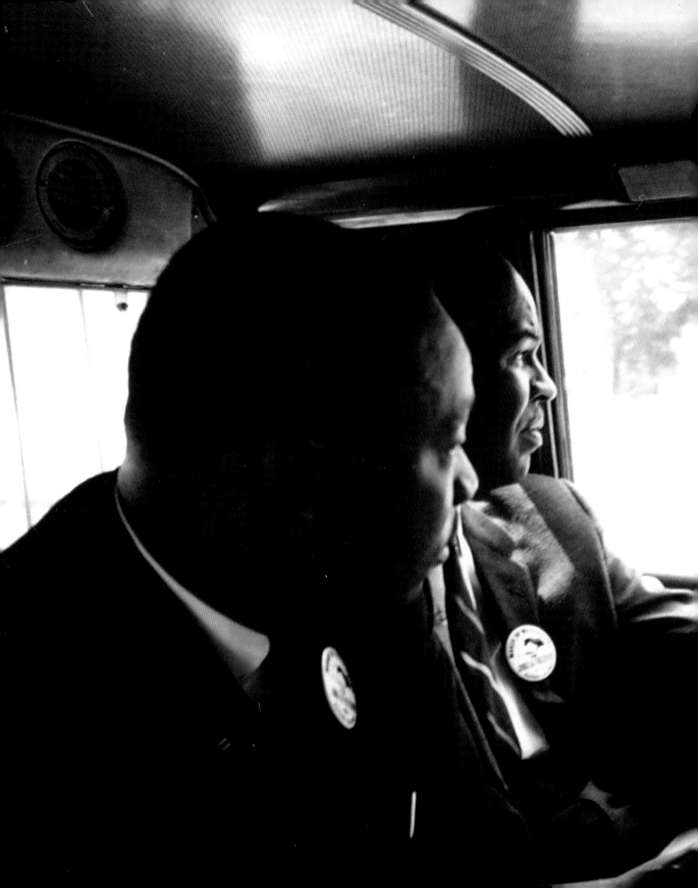

Martin Luther King, Jr., and Roy Wilkins look at the marchers gathering on the Mall, August 28, 1963, as they are driven to Capitol Hill to meet with congressional leaders.

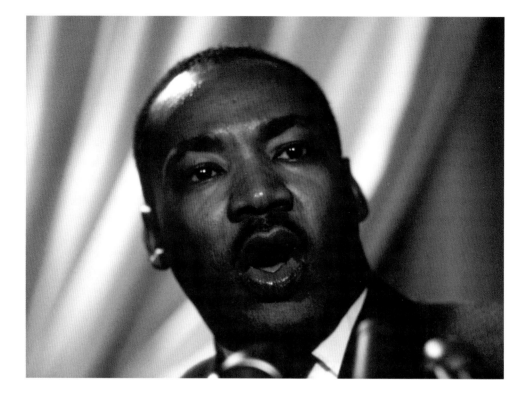

D URING A VISIT TO THE KENNEDY

White House, Martin Luther King, Jr., pressed the President to issue a second Emancipation Proclamation, which would completely outlaw segregation. Saying he would consider it, Kennedy asked King to submit a proposal. King envisioned Kennedy's Emancipation Proclamation to be announced on January 1, 1963, the centennial of Abraham Lincoln's Emancipation Proclamation, which ended slavery in the ten Confederate states not then under Union control. Lincoln's order freed 3.1 million slaves. Kennedy's order would free 19 million descendants of slavery.

"The time has come, Mr. President, to let those dawn-like rays of freedom, first glimpsed in 1863, fill the heavens with the noonday sunlight of complete human dignity," King wrote in his proposal.

The President was not persuaded. In fact, he purposely stayed away from all centennial celebrations of emancipation that year. He did, however, make an effort to protect the black vote by sending a special message to Congress on February 28, 1963, proposing the Voting Rights Act, which would include special safeguards to prevent discrimination in the South. He noted that voting rights were important in obtaining other rights. When the media pointed out that he had waited two years to address the issue, and then only slightly, Kennedy became defensive. He claimed that in the first two years

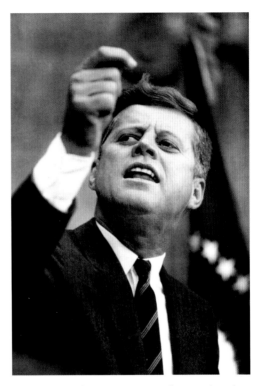

of his administration "more progress has been made in securing the civil rights of all Americans than in any comparable period in our history."

In more than one speech he would quote with a wry smile a verse said to have been found among the papers of a deceased legislator:

> Among life's dying embers
> These are my regrets:
> When I'm "right," no one remembers
> When I'm "wrong," no one forgets.

Before Birmingham, the President's primary focus was on foreign policy. After Birmingham, he was forced to recognize that the civil rights movement was as crucial as containing communism.

◆　◆　◆

While President Kennedy avoided any public celebration of the Emancipation Proclamation, his brother, the Attorney General, attended Kentucky's centennial in Louisville, on March 17, 1963, where he said that the United States is "turning a corner in a period of great and intense change" in race relations. Robert Kennedy cited racial gains achieved in his brother's administration but rapped the Soviet Union for its repression of rights, calling the Emancipation Proclamation "a torch that men will pass from hand to hand into every dark place in the world where slavery of one kind or another exists. This work will go forward firmly, without malice and with charity, not merely because of the cold war but, as the President has said, 'because it is right.'"

◆　◆　◆

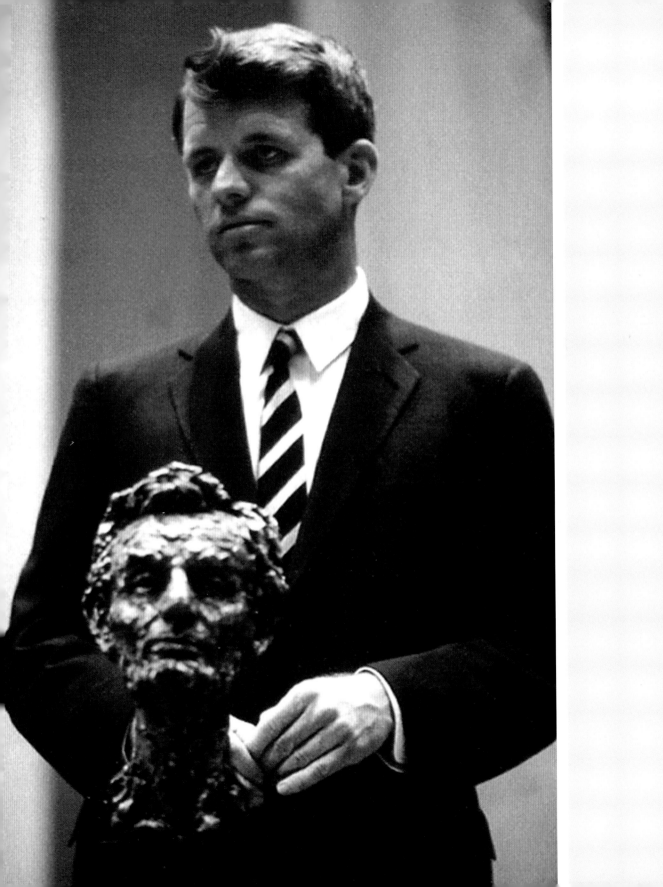

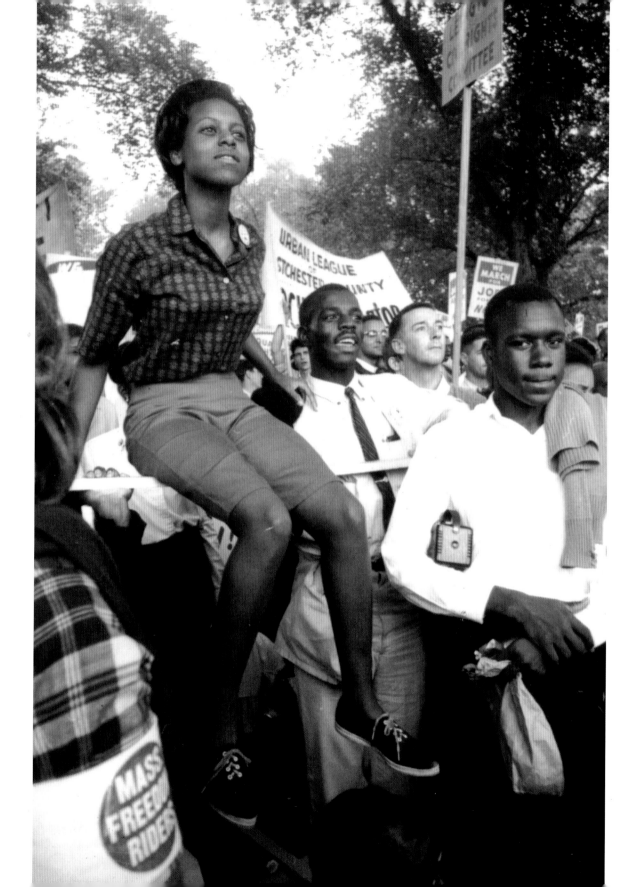

ALTHOUGH THE SUPREME COURT had outlawed segregation in interstate travel in 1960, black and white Freedom Riders were being attacked and beaten throughout the South from May through August of 1961. More than sixty Freedom Rides took place and more than 300 Freedom Riders were arrested, with little intervention from the Kennedy administration. Emboldened by the lack of federal force, the Ku Klux Klan continued their terrifying night rides, burning the buses of Freedom Riders, and attacking them with rocks, bottles, lead pipes, and baseball bats for attempting to use "White Only" bathrooms.

Violence escalated against blacks for trying to integrate lunch counters, department stores, parks, and public schools. Black churches were burned and black schools torched in the Carolinas, Georgia, Mississippi, Alabama, Arkansas, Tennessee, Texas, and Florida. Television coverage of the racist brutality flashed across the country, and introduced white America to the black acronyms of peaceful protest: CORE (Congress of Racial Equality), SNCC (Student Nonviolent Coordinating Committee), SCLC (Southern Christian Leadership Conference), and the NAACP.

THE FREEDOM RIDE WAS PROPOSED by James Farmer of CORE to test integration in the South and the Kennedy administration's commitment to civil rights laws. The strategy: An interracial group would board buses; whites would sit in the back and blacks in the front; at rest stops whites would go into black-only areas and blacks would go into white-only areas.

"This was not civil disobedience really," said Farmer, "because we [were] merely doing what the Supreme Court said we had a right to do. We felt we could count on the racists of the South to create a crisis so that the federal government would be compelled to enforce the law."

Beginning in Washington, D.C., on May 4, 1961, the Freedom Ride was scheduled to arrive in New Orleans on May 17, 1961, the seventh anniversary of *Brown vs. Board of Education*, which struck down segregation in public schools. The Freedom Ride split into two groups to travel through Alabama. On Mother's Day, May 14, both groups were attacked by angry white mobs of segregationists. The first bus was burned outside of Anniston, Alabama. The second was attacked in Birmingham.

Fearing for their safety, the Freedom Riders flew to New Orleans. But a group of students from Nashville took the bus to Birmingham to continue the Freedom Ride. "If the Freedom Riders had been stopped as a result of violence, I strongly felt that the future of the movement was going to be cut short," said Diane Nash,

who organized the Nashville group. "The impression would have been that whenever a movement starts, all [you have to do] is attack it with massive violence and the blacks [will] stop."

The Freedom Riders were arrested in Birmingham, driven back to Tennessee, and dumped on the side of the highway over the state line, 100 miles from Nashville. Once they got to Nashville, they went right back to Birmingham. By this point the Justice Department was involved and the Attorney General was negotiating with the governor of Alabama to protect the Freedom Riders on the 90 miles of highway between Birmingham and Montgomery.

Again the Freedom Riders were attacked by racist mobs. State troopers arrived but did little to hold back the rampage. Promised police protection, the Freedom Riders continued to Montgomery, where the police disappeared and the Freedom Riders were viciously beaten. The governor declared martial law and sent in the National Guard to restore order. The Freedom Riders continued to Jackson, Mississippi, where they were all arrested and sentenced to sixty days in the state penitentiary. More Freedom Riders arrived to continue the Freedom Ride, but they, too, were arrested. By the end of the summer of 1961 more than 300 had been arrested.

The Freedom Riders never made it to New Orleans but they forced the Kennedy administration to take a stand on civil rights, which was their intention in the first place.

SHORTLY AFTER BIRMINGHAM, James Baldwin along with Harry Belafonte and others met with Attorney General Robert F. Kennedy in his New York apartment. For nearly three hours the black activists upbraided the Attorney General for his insensitivity to the Negro's plight. Angrily, Kennedy tried to defend himself and his brother's administration. After all, he had hired African American attorneys at the Justice Department, appointed black U.S. attorneys, and expanded the civil rights division. Unimpressed, Baldwin, Belafonte, and the others said he was neglecting his constitutional responsibility by not using federal intervention to protect the legal rights of nonviolent black citizens, especially in court cases where racist judges and all-white juries dominated the judicial system.

The Attorney General reported the meeting to his brother. Days later the President met with the Senate Majority Leader, who said the administration must introduce civil rights legislation before the country imploded.

That afternoon, Kennedy received a telegram from Martin Luther King, Jr., urging him to stop the nightstick brutality of police in Danville, Virginia, against peaceful protestors. King wired: "The Negro's endurance may be at a breaking point."

The American writer James Baldwin would go on to attend the March on Washington, seen here with Julie Belafonte, wife of singer Harry Belafonte.

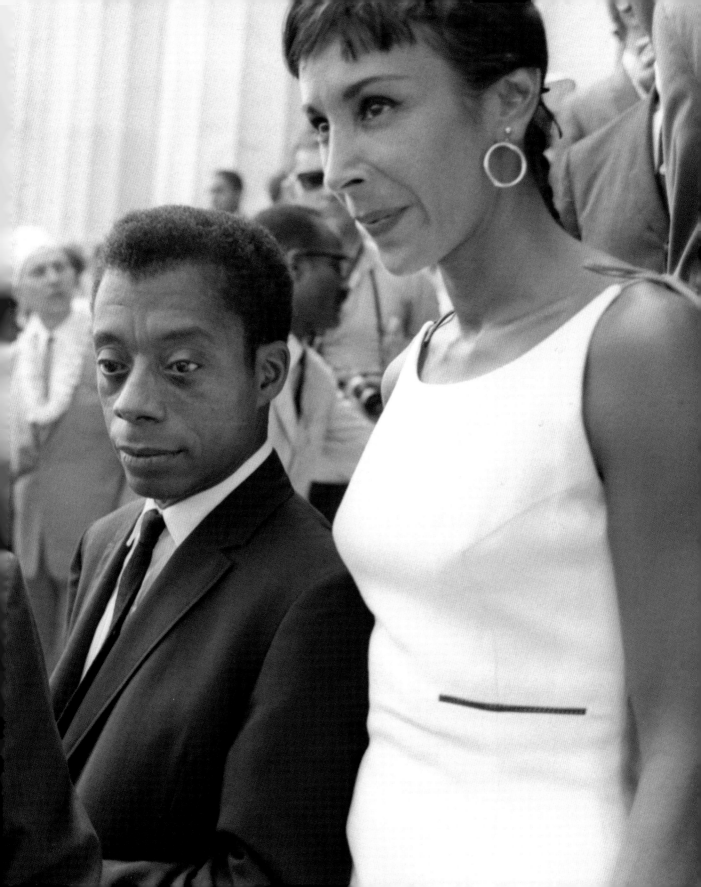

◆　　◆　　◆

Born in Harlem, James Baldwin (1924–1987) became disillusioned by American prejudice against blacks and homosexuals, and at the age of twenty-four, he moved to France, where he lived for the rest of his life. His best known novel, *Go Tell It on the Mountain*, was an autobiographical story of a young black man who faced a lifetime of rejection.

Baldwin traveled the South in 1963 on a lecture tour, speaking about civil rights. He became such a spokesman for the movement that he was featured on the cover of *Time*, which said: "There is not another writer, black or white, who expresses such poignancy and abrasiveness about the dark realities of the racial ferment in North and South."

◆　　◆　　◆

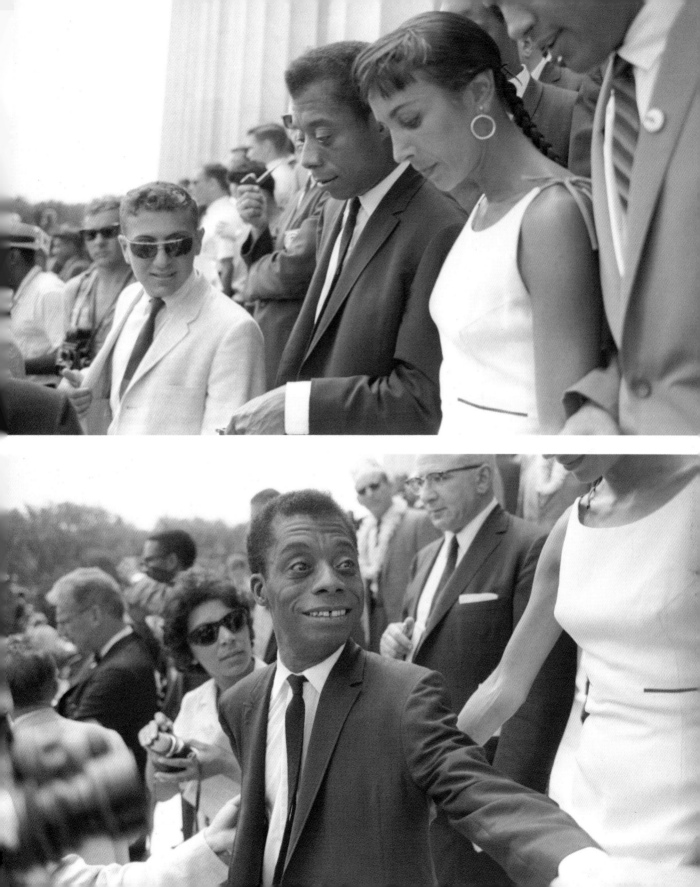

FOR the MARCH on WASHINGTON
BALDWIN WROTE a STATEMENT for the PERFORMING
ARTISTS from HOLLYWOOD and NEW YORK WHO
ATTENDED, WHICH WAS READ by CHARLTON HESTON
and HARRY BELAFONTE

We are here today a witness to what we know.

We know that this country, America, to which we are committed and which we love, aspires to become that country in which all men are free. We also know that freedom is not a license. Everyone in a democracy ought to be free to vote. But no one has the license to oppress or demoralize another.

We also know, or we would not be here, that the American Negro has endured for many generations in this country, which he helped to build, the most intolerable injustices. To be a Negro in this country means several unpleasant things. In the Deep South it often means that he is prevented from exercising his right to vote by all manner of intimidation up to and including death. This fact of intimidation is a great weight in the life of any Negro and though it varies in degree it never

varies in intent, which is simply to limit, to demoralize, and to keep in subservient status more than 20 million Negro people.

We are here, therefore, to protest this evil and to make known our resolve to do everything we can possibly do to bring it to an end. As artists and as human beings we rejoice in the knowledge that human experience has no color and that excellence in any endeavor is the fruit of individual labor and love, and we believe that artists have a valuable function in any society, since it is the artists who reveal the society to itself. But we also know that any society which ceases to respect the human aspirations of all its citizens courts political chaos and artistic sterility. We need the energies of these people to whom we have for so long denied full humanity. We need their vigor, their joy, the authority which their pain has brought them. In cutting ourselves off from them, we are punishing and diminishing ourselves. As long as we do so, our society is in great danger. Our growth as artists is severely menaced and no American can boast of freedom, for he cannot be considered an example of it. We are here then in an attempt to strike the chains which bind the ex-master no less than the ex-slave, and to invest with reality that deep and universal longing, which has sometimes been called "The American Dream."

◆　◆　◆

Attorney General Robert F. Kennedy, in a phone booth at La Guardia airport, March 9, 1963, calls the White House to report on his speech to the Civil Rights Committee of the New York City Central Labor Council, AFL-CIO. He had called for labor to support the administration's civil rights program, saying: "We would be dishonest with ourselves if we did not admit that some discrimination continues to exist in the labor movement."

He cited job discrimination among four trade unions working on a federally supported construction project at Howard University, a predominantly black institution in Washington, D.C.

Days after the Attorney General's speech, the Secretary of Labor issued a ten-day compliance order to contractors and unions, demanding an end to racial discrimination in hiring on all government contracts.

◆　◆　◆

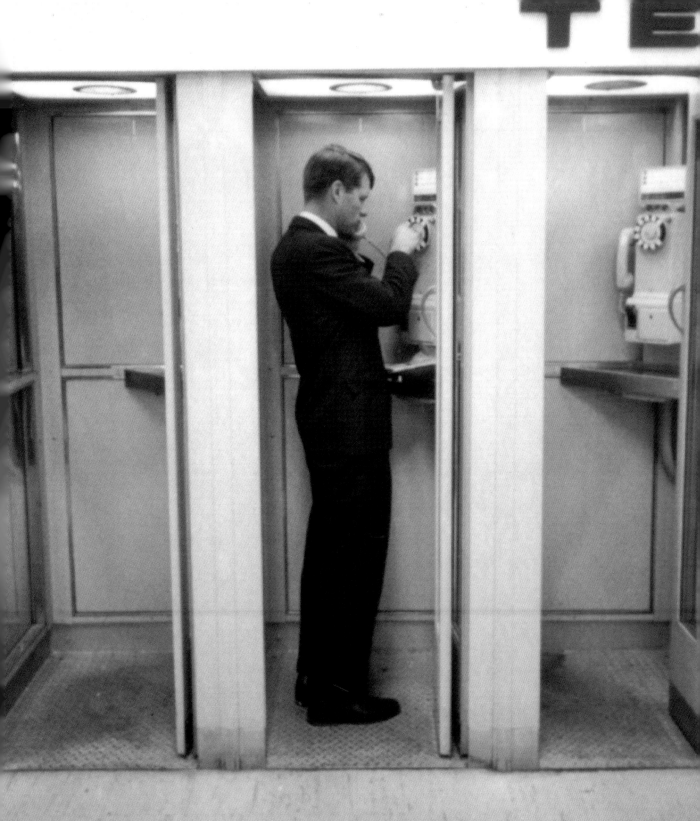

T HE PRESIDENT WATCHED coverage of Alabama Governor George C. Wallace, who had been threatening to "stand in the schoolhouse door" to prevent two black students from integrating the state's all-white university. Wallace vowed to keep his inaugural pledge of "Segregation now! Segregation tomorrow! Segregation forever!" by resisting a federal court order to admit the students, which he did on June 11, 1963. Kennedy was forced to order the National Guard to remove Wallace from "the schoolhouse door" so the black students could enroll. That night the President addressed the nation on the issue of race with eloquence:

This is not a sectional issue. Nor is this a partisan issue. This is not even a legal or legislative issue alone. We are confronted primarily with a moral issue. It is as old as the Scriptures and as clear as the American Constitution.

If an American, because his skin is dark, cannot eat lunch in a restaurant open to the public, if he cannot send his children to the best public schools available, if he cannot vote for the public officials who represent him ... then who among us

would be content to have the color of his skin changed? Who among us would then be content with counsels of patience and delay?

Next week I shall ask the Congress of the United States to make a commitment it has not fully made in this country to the proposition that race has no place in American life or law.

I am, therefore, asking the Congress to enact legislation giving all Americans the right to be served in facilities which are open to the public—hotels, restaurants, theaters, retail stores, and similar establishments. I am asking Congress to authorize the federal government to participate more fully in lawsuits designed to end segregation in public education. Other features will also be requested, including greater protection for the right to vote.

A FEW HOURS AFTER JFK'S address on national television, Medgar Evers, an organizer for the NAACP, was assassinated in Jackson, Mississippi. Standing in his driveway in front of his wife and children, he was shot in the back by a sniper. Evers was returning from a late meeting with NAACP lawyers and carrying some of the organization's T-shirts that read "Jim Crow Must Go." His murder caused a national uproar and his murderer, a member of the White Citizens Council and the Ku Klux Klan, was not convicted until 1994.

President Kennedy was staggered by the slaying. "You know, it's like they shoot this guy in Mississippi," he told one congressional leader. "I mean, it's just in everything. I mean, this has become everything." The President was appalled by the violence that followed his speech on civil rights and probably did not comprehend the depth of Southern racism.

A week after the murder of Medgar Evers, the President sent his bill for the Civil Rights Act to Congress, proposing that they remain in session until the legislation was passed. Not unexpectedly, the Dixiecrats threatened to filibuster, vowing to torpedo every future piece of legislation Kennedy sent to Capitol Hill.

Worried that the summer of 1963 would be as long and hot and violent as the previous two summers, the President met with civil rights leaders at the White House. He asked for a "cooling-off period" while Congress considered his proposed legislation. He said that continued demonstrations would do more harm than good in winning congressional approval of the sweeping civil rights package he had proposed.

The Big Six, so called because they represented the six engines fueling the civil rights movement, firmly rejected the President's request. "We cannot stop

now," they said. Speaking for CORE, James Farmer said: "We do not intend to call off demonstrations and we would not, if we could. The demand for freedom is not something that can be turned on and turned off."

Roy Wilkins, secretary of the NAACP, told the President that demonstrations were a part of the American tradition of protest.

Julian Bond, communications director for SNCC, said: "We cannot in good conscience ask American citizens who have been denied their rights for two hundred years to refrain from voicing their demands in any way they choose."

Dr. Martin Luther King, Jr., of SCLC; Whitney Young, executive director of the Urban League; and A. Philip Randolph, president of the Brotherhood of Sleeping Car Porters, also expressed their objections to the President's moratorium.

Knowing Kennedy was leaving on a trip to Europe and would not be in Washington to muscle his legislation through Congress, King decided that a mass protest march was needed to make senators and representatives pay attention to the matter of civil rights. Speaking to reporters after meeting with the President, King said: "I made it very clear we could not in all good conscience call off any massive demonstrations, until the problems that brought these demonstrations into being are solved."

Randolph, 74, the esteemed elder of the movement, had been planning a march on Washington for October 1963, but Dr. King asked him to move up the date to put pressure on Congress while debating the bill. Randolph agreed, secured the united support of the Big Six, and announced their march on the nation's capital.

Martin Luther King, Jr., shown on the steps of a Chicago tenement, knew that the fight for equality was not limited to the South. "In the South the civil rights movement has been able to offer some hope to the Negro," he said in 1963, "but the situation is more difficult in the North. Here bias is illegal but subtle. The Negro here, jobless, penned in ghettos, sees only retrogression, not hope. That's why he's ready to march."

Dr. King seemed to echo the words of Abraham Lincoln when he signed the Emancipation Proclamation in 1863 and indicted the North's lack of response to the deprivation of rights: "The North responds to the proclamation sufficiently in breath."

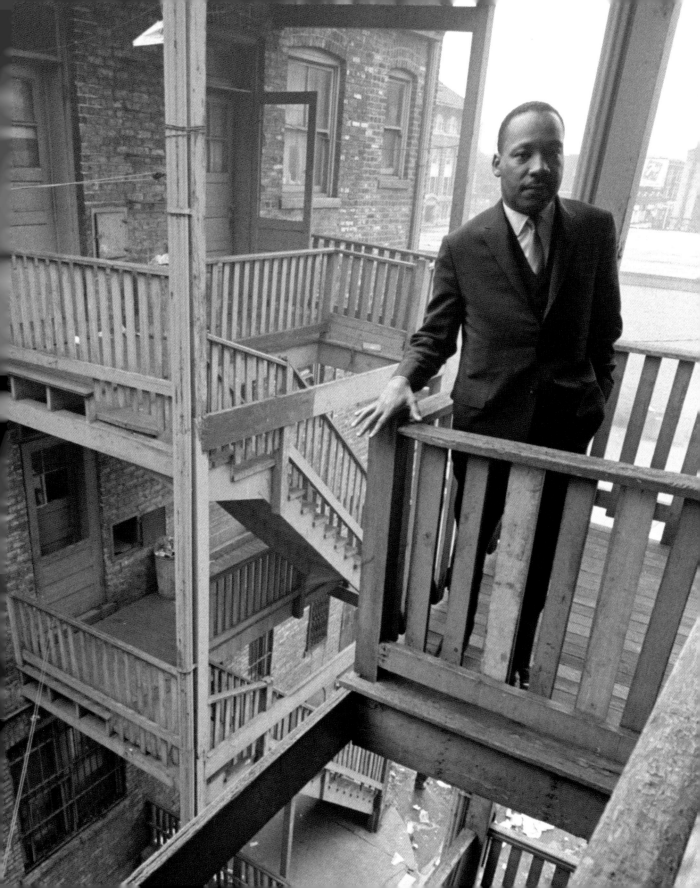

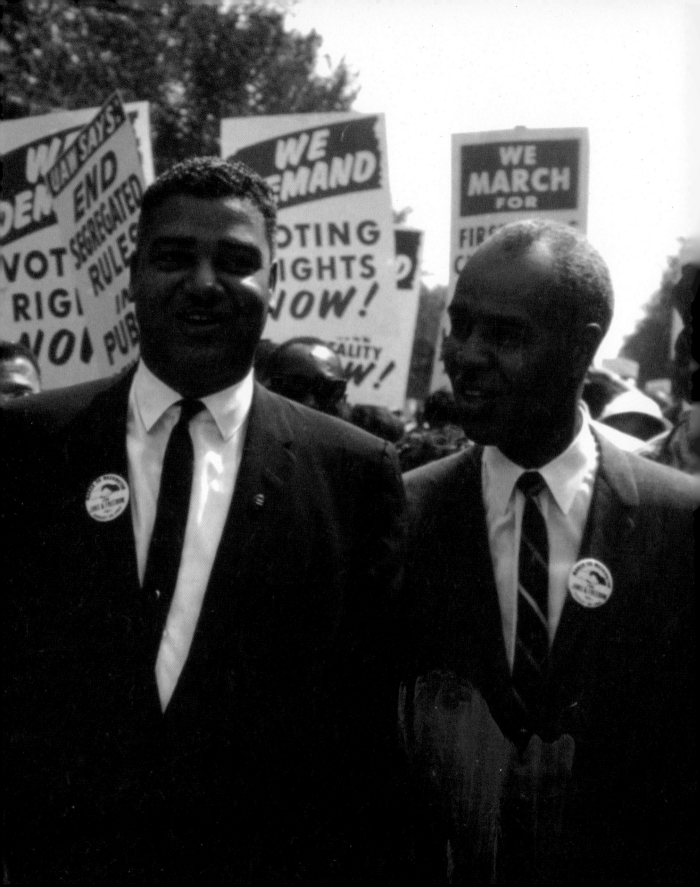

◆　◆　◆

Whitney Young (1921–1971), one of the Big Ten, served as Executive Director of the National Urban League at a time when the organization had to become more concerned with social change than social services. After serving in World War II, Young graduated with a master's in social work from the University of Minnesota. He represented moderation within the civil rights movement, advocating "responsible leadership using legally accepted methods."

He developed close ties with business leaders for help in hiring black workers. With his published book and syndicated newspaper columns, he heightened the visibility of the Urban League and became a close ally of President Johnson, who gave him the Medal of Freedom in 1969—in no small part for his support of the war in Vietnam, which Martin Luther King, Jr., and other civil rights leaders opposed, saying that "military investment in Vietnam diverted resources away from the urgent problems facing African Americans at home."

◆　◆　◆

This march must go beyond this historic moment. For the true test of the rededication and the commitment which should flow from this meeting will be in our recognition that however impressed or however incensed our congressional representatives are by this demonstration, they will not act because of it alone.

We must support the strong, we must give courage to the timid, we must remind the indifferent, and warn the opposed. Civil rights, which are God-given and constitutionally guaranteed, are not negotiable in 1963.

Furthermore, we must work together even more closely back home, where the job must be done to see that Negro

Americans are accepted as first-class citizens and that they are able to do some more marching.

They must march from the cemeteries, where our young, our newborn, died three times sooner and our parents die seven years earlier. They must march from there to nearby established health and welfare centers.

They must march from the congested, ill-equipped schools, which breed dropouts and which smother motivation to the well-equipped integrated facilities throughout the cities. And finally they must march from a present feeling of hopelessness, despair, and frustration to a renewed faith and confidence due to tangible programs and visible changes made possible only by walking together.

◆　　◆　　◆

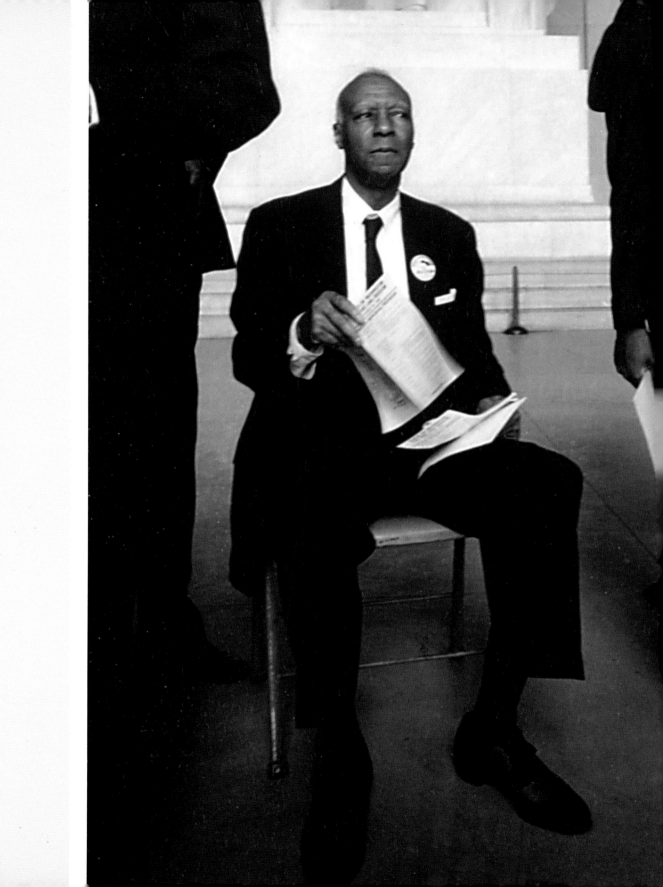

A. Philip Randolph (1889–1979), another member of the Big Ten, directed the March on Washington for Jobs and Freedom. Active in civil rights all his life, Randolph had been planning this march for many years. In 1941 he had called for a march on Washington "to win the full benefits of democracy for the Negro people." The focus then was to press President Roosevelt for equality in federal employment. That march was called off when Roosevelt issued Executive Order 8802, which outlawed defense industry discrimination and established the Committee on Fair Employment. Randolph proposed a march again in 1948, demanding integration of the armed forces. When President Truman signed an executive order banning segregation in the military, Randolph called off that march. However, he insisted on the 1963 march because he said President Kennedy's civil rights bill was too "weak" and did not contain a fair employment law.

Our white allies know they cannot be free while we are not, and we know we have no future in a society in which six million black and white people are unemployed and more live in poverty.

Yes, we want all public accommodations open to all citizens, but those accommodations will mean little to those who cannot afford to use them. Real freedom will require many changes.

It falls to the Negro to reassert this priority of values because our ancestors were transformed from human personalities into private property. It falls to us also to demand new forms of social planning to create full employment. We are the worst victims of unemployment so we have taken our struggle

into the streets, as the labor movement took its struggle into the streets. Until we went into the streets the federal government was indifferent to our demands.

It was not until the streets and jails of Birmingham were filled that Congress began to think about civil rights legislation. Not until thousands demonstrated in the South that lunch counters were integrated.

Look for the enemies of Medicare, of higher minimum wages, of Social Security, of federal aid to education—and there you will find the enemy of the Negro: the coalition of Dixiecrats and reactionary Republicans that seek to dominate Congress.

We shall return again and again in Washington in ever growing numbers until total freedom is ours. We shall settle for nothing else.

◆　　◆　　◆

A. PHILIP RANDOLPH, MORE than two decades after first calling for a march on Washington, was now challenging another president with a march that would not be called off. He stressed that this march would be for more than the passage of a civil rights bill he deemed "insufficient." This march would be a massive demonstration for freedom and jobs. With Bayard Rustin, his brilliant deputy, Randolph reached out to churches, civil rights organizations, and unions. Soon the Big Six became the Big Ten with the addition of four white men: Walter Reuther, United Auto Workers; Dr. Eugene Carson Blake, National Council of Churches; Rabbi Joachim Prinz, American Jewish Congress; and Mathew Ahmann, National Catholic Conference for Interracial Justice. Ironically, no women were represented in the hierarchy: the black men fighting to rid the nation of "White Only" signs did not include the black women who also suffered under segregation.

The Big Ten: Back row, left to right: Mathew Ahmann, Rabbi Joachim Prinz, John Lewis, Eugene Carson Blake, Floyd McKissick, Walter Reuther. Front row, left to right: Whitney Young, Cleveland Robinson (administrative chairman of the March but not officially a member of the Big Ten), A. Philip Randolph, Martin Luther King, Jr., and Roy Wilkins.

They are sitting in front of the statue of Lincoln, above which is carved in marble:

In this temple

As in the hearts of the people

For whom he saved the union

The memory of Abraham Lincoln

Is enshrined forever

IN THIS TEMPLE
AS IN THE HEARTS OF THE PEOPLE
FOR WHOM HE SAVED THE UNION
THE MEMORY OF ABRAHAM LINCOLN
IS ENSHRINED FOREVER

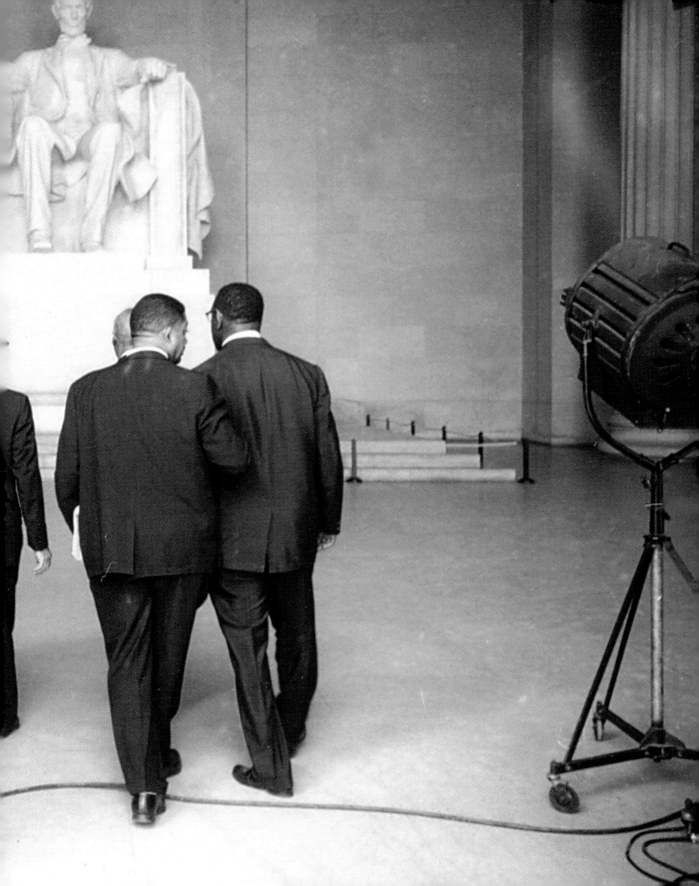

◆　　◆　　◆

Mathew Ahmann (1931–2001), one of the Big Ten, was Executive Director of the National Catholic Conference for Interracial Justice. He organized the National Conference on Religion and Race, held in January 1963. This conference clearly defined the civil rights movement as a moral cause.

Editor of *The New Negro* (1961) and *Race: Challenge to Religion* (1963), and with Margaret Roach *The Church and the Urban Racial Crisis* (1967), Ahmann also served as one of the organizers of the March on Washington held at the Lincoln Memorial August 28, 1963. Ahmann was the least well-known of the Big Ten organizers but a powerful catalyst for bringing the Catholic Church into the civil rights movement.

◆　　◆　　◆

Who can call himself a man, say he is created by God, and at the same time take part in a system of segregation which destroys the livelihood, the citizenship, family life, and the very heart of the Negro citizens of the United States?

Who can call himself a man, and take part in a system of segregation which frightens the white man into denying what he knows to be right, into denying the law of his God?

We dedicate ourselves today to secure federal civil rights legislation which will guarantee every man a job based on his talents and training; legislation which will do away with the myth that the ownership of a public place of business carries the moral or legal right to reject a customer because of the color of his hair or of his skin.

We dedicate ourselves to guarantee by legislation that all American citizens have integrated education and the right to vote on reaching legal age. We dedicate ourselves today to secure a minimum wage which will guarantee a man or a woman the resources for a vital and healthy family life, unencumbered by uncertainty and by racial discrimination. A good job for every man is a just demand and it becomes our motto.

But we are gathered too to dedicate ourselves to building a people, a nation, a world which is free of the sin of discrimination based on race, creed, color, or national origin, a world of the sons of God, equal in all important respects; a world dedicated to justice and to fraternal bonds between men.

◆　　◆　　◆

Eugene Carson Blake (1906–1985) was C.E.O. of the
United Presbyterian Church in the United States and
as a member of the Big Ten, represented the National
Council of Churches. An urbane, tough-minded
liberal, he attended Lawrenceville School, Princeton,
and Princeton Theological Seminary. He opposed
McCarthyism in the 1950s and was attacked by con-
servative fundamentalists as a Communist. He was in
the forefront of the civil rights movement and was
arrested for demonstrating in Baltimore in 1963.

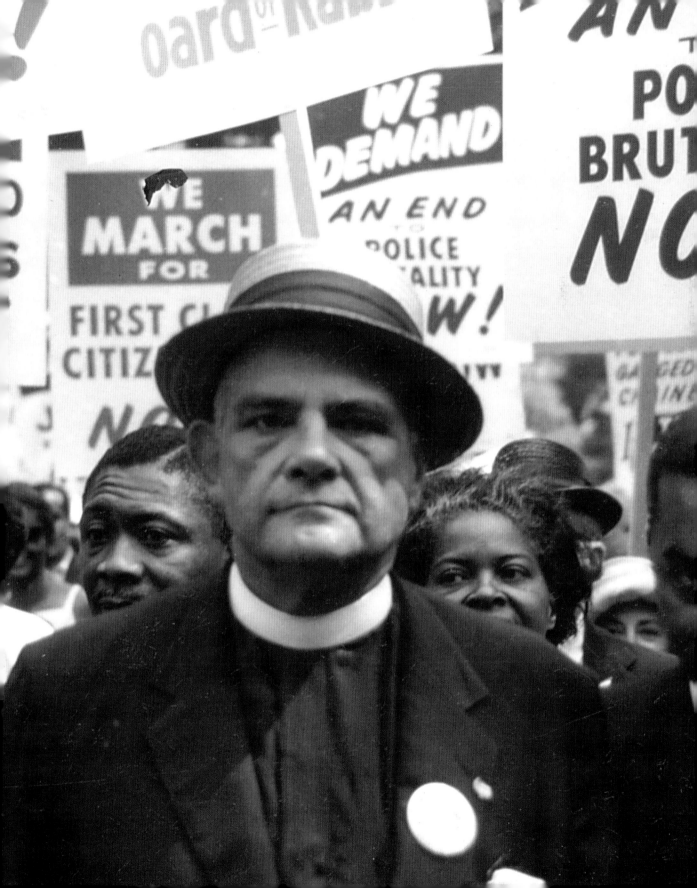

For many years now the National Council of Churches and most of its constituent communions have said all the right things about civil rights. Our official pronouncements for years have clearly called for "a nonsegregated church in a nonsegregated society." But as of August 28, 1963, we have achieved neither a nonsegregated church nor a nonsegregated society.

And it is partially because the churches of America have failed to put their own houses in order that 100 years after the Emancipation Proclamation, 175 years after the adoption of the Constitution, 173 years after the adoption of the Bill of Rights, the United States of America still faces a racial crisis.

We do not, therefore, come to this Lincoln Memorial in any arrogant spirit of moral or spiritual superiority to "set the nation straight" or to judge or to denounce the American people in whole or in part.

Rather, we come—late, late we come—in the reconciling and repentant spirit in which Abraham Lincoln of Illinois once replied to a delegation of morally arrogant church men: "Never say God is on our side, rather pray that we may be found on God's side."

We come in the fear of God that moved Thomas Jefferson of Virginia, whose memorial stands across the lagoon, to say: "Indeed, I tremble for my country, when I reflect that God is just."

◆ ◆ ◆

♦ ♦ ♦

Rabbi Joachim Prinz (1902–1988), also a member of the Big Ten
and President of the American Jewish Congress, was expelled
from Germany in 1937 by Adolf Eichmann when Prinz was rabbi
of the Berlin Jewish community. He became a U.S. citizen in
1944. The author of several books, Prinz fought against anti-
Semitism, defended civil liberties, and opposed government aid
to religious and private schools. A lifelong Zionist, Prinz left the
movement in 1948 when Israel became a nation and he perceived
Zionism to be obsolete, a position he shared with David Ben-
Gurion but which brought him much criticism. Prinz won a libel
suit against a right-wing magazine that called him a Communist.

♦ ♦ ♦

When I was the rabbi of the Jewish community in Berlin under the Hitler regime, I learned many things. The most important thing that I learned in my life and under those tragic circumstances is that bigotry and hatred are not the most urgent problem. The most urgent, the most disgraceful, the most shameful, and the most tragic problem is silence.

A great people which had created a great civilization had become a nation of silent onlookers. They remained silent in the face of hate, in the face of brutality and in the face of mass murder.

America must not become a nation of onlookers. America must not remain silent. Not merely black America, but all of America. It must speak up and act, from the President down to the humblest of us, and not for the sake of the Negro, not for the sake of the black community, but for the sake of the image, the idea, and the aspiration of America itself.

Our children, yours and mine in every school across the land, every morning pledge allegiance to the flag of the United States and to the republic for which it stands, and then they, the children, speak fervently and innocently of this land of "liberty and justice for all."

◆ ◆ ◆

◆　◆　◆

Walter Reuther (1907–1970), another member of the Big Ten, served as President of the United Automobile Workers Union, and as Vice President and head of the Industrial Union Department of the AFL-CIO. Coming from the political left as a young man, Reuther quit the Socialist party and helped found Americans for Democratic Action. A masterful debater, he was considered the most gifted man in the labor movement and played a crucial role in merging the AFL and CIO. Yet he publicly criticized the AFL-CIO for its failure to endorse the March on Washington in 1963: "Their statement is so anemic that you'd have to give it a blood transfusion to keep it alive on the way to the mimeograph machine," Reuther told *The New York Times*. Like most other civil rights leaders, he opposed the war in Vietnam.

◆　◆　◆

There is a lot of noble talk about brotherhood and then some Americans drop the brother and keep the hood.

For one hundred years the Negro people have searched for first-class citizenship and I believe that they cannot and should not wait until some distant tomorrow. They should demand freedom now. Here and now. It is the responsibility of every American to share the impatience of the Negro-Americans. And we need to join together to march together, and to work together until we have bridged the moral gap between American democracy's noble promises and its ugly practices in the field of civil rights.

I take the position if we can have full employment and full production for the negative ends of war then why can't we have a job for every American in the pursuit of peace?

If we fail, the vacuum of our failure will be filled by the apostles of hatred who will search in the dark of night. And reason will yield to riots, and brotherhood will yield to bitterness and bloodshed, and we will tear asunder the fabric of American democracy.

So let this be the beginning of that great crusade to mobilize the moral conscience of America so that we can win freedom and justice and equality and first-class citizenship for every American, not just for certain Americans, not only in certain parts of America, but in every part of America from Boston to Birmingham, from New York to New Orleans, and from Michigan to Mississippi.

◆ ◆ ◆

P RESIDENT KENNEDY MET WITH various community leaders from around the country to discuss the racial issue, and after his eighth White House meeting he summoned the civil rights leaders. "We're up to our necks in this," he said, stressing that his administration had taken a strong stand for them. He emphasized that he thought their plan for a big march on Washington was a mistake. "We want success in Congress, not a big show at the Capitol."

The civil rights leaders let the President know the "big show at the Capitol" could not be cancelled. "The Negroes are already in the streets," said Randolph. "If they are bound to be in the streets in any case is it not better that they be led by organizations dedicated to civil rights and disciplined by struggle rather than to leave them to other [more militant] leaders who care neither about civil rights nor nonviolence?"

The President, whose approval rating had plummeted from 60 to 47 percent after he proposed his civil rights bill, shook his head. "Look, you've got your problems, but remember that I have my problems." His major concern about the March was upheaval in the nation's capital that could lead to violence and, subsequently, to his defeat for reelection. Dr. King tried to reassure him when he spoke to reporters later: "I would not go along with violent demonstrations at any time," King said, adding that violence usually was caused by "bystanders or brutal police forces. I would be the first to urge everyone engaged to call them off. But [this] will be a peaceful, nonviolent demonstration."

The President later met with the Attorney General. "Well," he said, "if we can't stop them, we'll run the damn thing."

This was not lost on Malcolm X, a leader of the Black Muslims. "When the white man found out he couldn't stop it, he joined it," he said. He urged his followers to "get the great white ape off our backs. The big white ape named Uncle Sam." The Black Muslims advocated a separate state for American Negroes.

The Attorney General immediately began meetings with his staff at the Justice Department, the FBI, March organizers, and Metropolitan police.

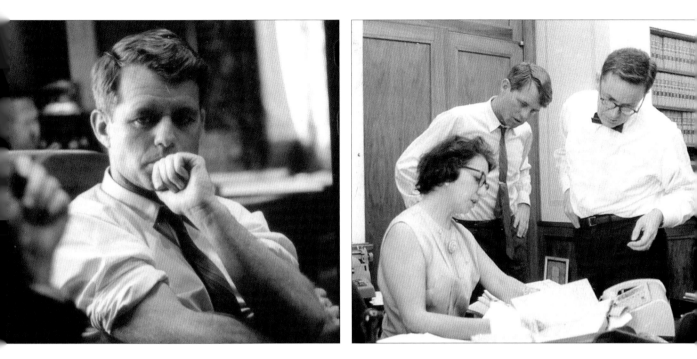

He managed to dissuade the organizers from staging any acts of civil disobedience in the halls of Congress. He told the police not to use dogs for crowd control, in order to avoid repeating the ugly images of Birmingham. The D.C. police force was to dispatch 5,600 officers to patrol the parade, and the FBI to place 150 agents on the streets to mingle with the crowds. He insisted the March be held in the middle of the week so that marchers would not be tempted to stay the weekend and run riot through the streets. Parade permits would restrict march-ers to the area from the Washington Monument to the Lincoln Memorial. They were to assemble at 9 A.M. and leave the city by 5 P.M., before dark.

(left) **Robert F. Kennedy at a staff meeting in his Justice Department office in March 1963.** *(right)* **Robert F. Kennedy standing between his secretary Angela Novello and Burke Marshall, head of the Justice Department.**

WEEKS BEFORE THE EVENT,

the March on Washington for Jobs and Freedom became a running story on the front pages of the nation's newspapers and was reported nightly on national television. Crowd estimates rose by the day: from 100,000 to 150,000 to well over 200,000 people planning to travel to the nation's capital to hear singers and speakers at the Lincoln Memorial.

The federal government would shut down for the day of the March and federal employees were encouraged to stay at home. All District liquor stores were closed and alcohol was banned for the first time since Prohibition. Most D.C. businesses, downtown stores, and restaurants were shuttered as well. The Washington Senators postponed their baseball game, and all elective surgeries were cancelled at area hospitals to free up 340 beds for possible riot-related emergencies. The D.C. National Guard spent its annual summer camp training for riot duty and 2,400 Guardsmen were sworn in as "special officers" with temporary arrest powers. Local judges were placed on round-the-clock standby, and inmates were evacuated from District jails to create space for disruptive protestors.

Washington, D.C., was the first large city in the United States with a majority black population (55 percent), but the stranglehold of segregation could still be seen in 1963: Blacks could not try on clothes in downtown stores, few blacks were allowed to drive buses, and black police officers could not ride in squad cars with white officers. Many in the city's white establishment, including those sympathetic to civil rights, feared the March on Washington would be a disaster for the District of Columbia. Mrs. Agnes E. Meyer, whose family owned *The Washington Post* and *Newsweek*, predicted "catastrophic outbreaks of violence, bloodshed, and property damage." What she and most everyone else feared was disruption coming from the American Nazi Party, the Ku Klux Klan, the White Citizens' Councils, and the John Birch Society.

Comedian Dick Gregory, a civil rights activist, attended the March on Washington, predicting (rightly) that despite the fears of the white establishment the event would be as sweet as a church picnic. An outspoken critic of U.S. involvement in Vietnam, Gregory was an advocate of civil disobedience and was arrested several times for peacefully protesting for equal rights.

"I know the senators and congressmen are scared of what's going to happen," Gregory told the deputy attorney general. "I'll tell you what's going to happen. It's going to be a great big Sunday picnic." To the Kennedy administration, it looked like it was going to be a great big political fiasco.

Gregory was one of many to be arrested on May 6, 1963, after the "Children's March" in Birmingham, Alabama, known as the "Bastille of segregation." More nonviolent civil rights protestors were arrested on that one day than on any other day in American history.

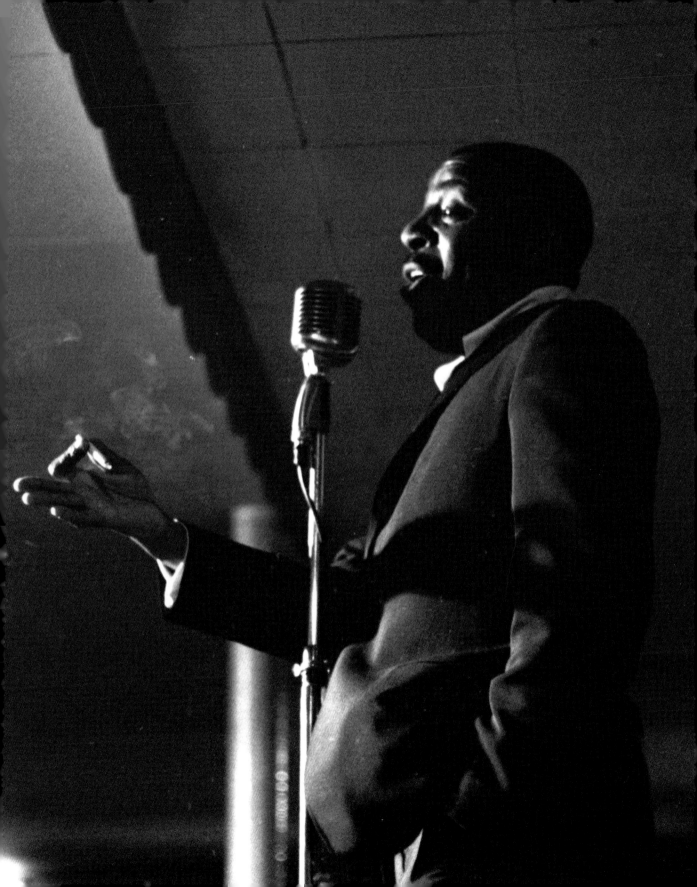

♦ ♦ ♦

After spending four days in jail, Gregory flew home to Chicago and returned to Birmingham a week later to address a civil rights rally. He talked about his arrest and his commitment to the movement, telling his hard truths with soft humor:

"I'll tell you one thing, it sure is nice being outta that prison over there. Lot of people asked me when I went back to Chicago last night, they said: 'Well how are the Negroes in Birmingham taking it? What did they act like? What did they look like?'

"I said, 'Man, I got off a plane at ten-thirty, arrived at the motel at eleven, and by one o'clock I was in jail.' [Laughter]

"So I know what you all mean when you refer to the good old days. I asked one guy, 'What is the good old days?' and he said, '10 B.C. and 15 B.C.' I said, 'Baby, you're not that old,' and he said, 'Nah...I mean ten, fifteen, years before Bull Connor got here.'"

♦ ♦ ♦

An Appeal to You from

JAMES FARMER
Congress of Racial Equality

MARTIN LUTHER KING
Southern Christian
Leadership Conference

JOHN LEWIS
Student Non-violent
Coordinating Committee

A. PHILLIP RANDOLPH
Negro American Labor Council

ROY WILKINS
National Association for the
Advancement of Colored People

WHITNEY YOUNG
National
Urban League

to
MARCH ON WASHINGTON

America Faces a crisis...

Millions of Negroes are denied freedom...

Millions of citizens, black and white, are unemployed...

Discrimination and economic deprivation plague the nation and rob all people, Negro and white, of dignity and self-respect. As long as black workers are disenfranchised, ill-housed, denied education and economically depressed, the fight of white workers for a decent life will fail.

Thus we call on all Americans to join us in Washington:

- **to demand the passage of effective civil rights legislation which will guarantee to all**

 ... decent housing

 ... access to all public accommodations

 ... adequate and integrated education

 ... the right to vote

- **to prevent compromise or filibuster against such legislation**

- **to demand a federal massive works and training program that puts all unemployed workers, black and white, back to work**

- **to demand an FEP Act which bars discrimination by federal, state and municipal governments, by employers, by contractors, employment agencies and trade unions**

- **to demand a national minimum wage, which includes all workers, of not less than $2.00 an hour.**

In your community, groups are mobilizing for the March. You can get information on how to go to Washington from civil rights organizations, religious organizations, trade unions, fraternal organizations and youth groups.

JOIN THE MARCH ON WASHINGTON FOR JOBS AND FREEDOM
and become part of the great American revolution for human freedom and justice **Now.**

National Office—

MARCH ON WASHINGTON FOR JOBS AND FREEDOM
170 West 130 Street **New York 27, New York**

Cleveland Robinson
Chairman, Administrative Committee

Bayard Rustin
Deputy Director

THE MARCH ON WASHINGTON soon became a global event, as civil rights activists around the world announced that they, too, would march on August 28 in Berlin, Munich, Amsterdam, London, Oslo, Madrid, The Hague, Tel Aviv, Cairo, Toronto, and Kingston, Jamaica. More than sixteen hundred special press passes were issued to reporters and photographers and cameramen. American network television planned coverage, as did the BBC, which would give the March the most intensive media coverage of any event in Washington, D.C., since the April 14, 1945, funeral of President Franklin Delano Roosevelt.

The Kennedy administration was so concerned about hot rhetoric stirring the crowds to revolt that Jerry Bruno, one of the President's advance men, was to be positioned behind the sound system at the Lincoln Memorial ready to flip a special switch that would cut the power on the public address system, if necessary, and play a recording of Mahalia Jackson singing "He's Got the Whole World in His Hands."

The Kennedys' fears of a fiasco heightened when they received a copy of the speech that John Lewis, the president of SNCC, planned to deliver. The sentence that perturbed the President read: "In good conscience we cannot support the administration's civil rights bill, for it's too little too late." Lewis, who would become the Representative from Georgia's 5th district in 1986, had suffered massive beatings during his peaceful protests for equal rights, and he lacerated the President for proposing a bill that did not protect blacks from police brutality and civilian violence, and did not guarantee blacks the right to vote.

◆ ◆ ◆

John Lewis (b. 1940–), Chairman of the SNCC, was the youngest of the civil rights leaders. He had been arrested twenty-four times in nonviolent demonstrations and beaten and bloodied by white mobs during the Freedom Rides. As a teenager he was inspired by the radio sermons of Martin Luther King, Jr., and wanted to be a minister. Despite his shyness he became a regular preacher at Baptist churches around Troy, Alabama. In college he took up the cause of civil rights, and dedicated himself to its goals, always in peaceful pursuit.

Lewis, who had witnessed the seeds of hate sown by George Wallace, the segregationist governor of Alabama, had almost been killed by racist mobs reacting to Wallace's inflammatory rhetoric: "He never fired a gun," said Lewis, "but he created the climate and the conditions that encouraged vicious attacks against innocent Americans."

◆ ◆ ◆

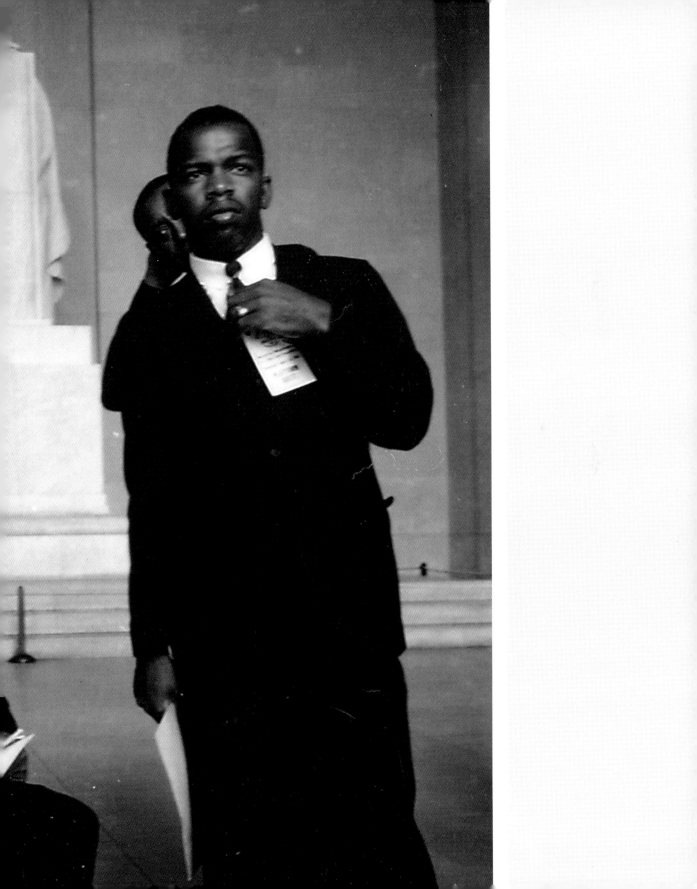

The administration's civil rights bill...[will not] protect young children and old women from police dogs and fire hoses...the citizens in Danville, Virginia, who must live in constant fear in a police state...the hundreds of thousands of people who have been arrested on trumped-up charges...the three young men... who face the death penalty for engaging in peaceful protest... the citizens of Mississippi...who are qualified to vote, but lack a sixth-grade education...the equality of a maid who earns $5 a week in the home of a family whose income is $100,000 a year.

To those who have said, "Be patient and wait," we must say that we cannot be patient. We do not want our freedom gradually but we want to be free now. We are tired. We are

tired of being beat by policemen. We are tired of seeing our people locked up in jail over and over again, and then you holler, "Be patient." How long can we be patient? We want our freedom and we want it now.

"One man, one vote" is the African cry. It is ours too. It must be ours. We must have legislation that will protect the Mississippi sharecropper who has been put off his farm because he dared to register to vote. We need a bill that will provide for the homeless and starving people of this nation.

[I]n the Delta of Mississippi, in Southwest Georgia, in the black belt of Alabama, in Harlem, in Chicago, Detroit, Philadelphia, and all over this nation the black masses are on the march for jobs and for freedom.

◆　　◆　　◆

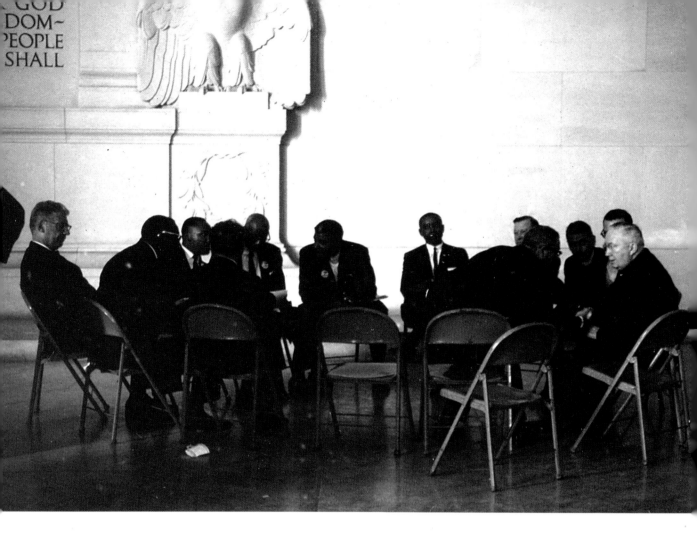

GOD
DOM-
PEOPLE
SHALL

Reverend Patrick J. O'Boyle, Catholic archbishop of Washington, D.C., and a staunch Kennedy supporter, objected to the militant tone of Lewis's speech, especially the passage that read "patience is a dirty and nasty word." O'Boyle refused to give the invocation for the March unless Lewis deleted his strident language, particularly what the archbishop perceived as Lewis's call for potential violence: "We will not wait for the President, the Justice Department, nor the Congress but we will take matters into our own hands and create a source of power, outside of any national structure, that could and would assure us victory."

(above) Civil rights activists meet in the Lincoln Memorial. Reverend Patrick J. O'Boyle appears far right, in foreground.

Lewis objected to making any changes in his speech but said later that A. Philip Randolph looked as if he might cry. "I've waited all my life for this opportunity," he said. "Please don't ruin it. We've come this far together. Let us stay together." So Lewis finally relented and deleted his jabs at "cheap political leaders."

Randolph had written to the President requesting a meeting with the Big Ten at the White House on the morning of the March. Kennedy knew such a meeting would be a press event with photographers, and he did not want to publicly associate himself with what he felt would be a political disaster. He had already

ON *the* DAY *of the* MARCH, WASHINGTON WAS VIRTUALLY UNDER MARTIAL LAW, *and* ACTING LIKE *a* CITY SOON *to be* UNDER SIEGE.

declined to deliver a speech at the Lincoln Memorial, because he feared his words might be booed on a world stage. He reassured Randolph that his government would continue providing every resource possible for the marchers' safety, and he invited the leaders to come to the White House after the March, but until then, the President kept his distance.

On the day of the March, Washington was virtually under martial law, and acting like a city soon to be under siege. Every military base in the area—Fort Myer, Fort Belvoir, Marine Corps Base Quantico, and Anacostia Naval Station—was on high alert. The army sent 4,000 troops in case of emergency to work with the D.C. National Guard, Metropolitan police, and National Park police, totaling 8,150 men. March organizers had worked all night at the Lincoln Memorial to set up the stage, erect bleachers for VIP guests, install the organ, and test the sound system.

UGUST 28, EARLY IN THE MORNING, the special trains began arriving at Union Station, where the marchers were greeted by March captains and escorted to shuttle buses to take them to the Mall. March leaders—the Big Ten—were driven to Capitol Hill to meet with congressional leaders. All members of Congress had been invited to attend the rally but only 20 senators out of 100 and 130 representatives out of 435 chose to be present. When they walked to their seats at the foot of the Lincoln Memorial the crowds shouted: "Pass the President's bill. Pass the bill. Pass the bill."

As the assembled masses began their march from the Washington Monument to the Lincoln Memorial they could hear majestic organ pipes and recurrent choruses of "We Shall Overcome." Later they would be entertained by the folk singer Odetta with songs of such spirit and emotion that they broke into spontaneous shouts of joy. They clapped as singer after singer sang folk songs and spirituals. They swayed in massive waves when the SNCC Freedom Singers sang "I Want My Freedom Now." They joined their voices with Peter, Paul and Mary to sing "If I Had a Hammer"; they fell silent as Bob Dylan moaned "Only a Pawn in Their Game," his musical tribute to Medgar Evers; and they roared when Joan Baez filled the air with her liquid gold voice, singing:

> Hush little baby, don't you cry
> You know your mama was born to die
> All my trials, Lord, soon be over

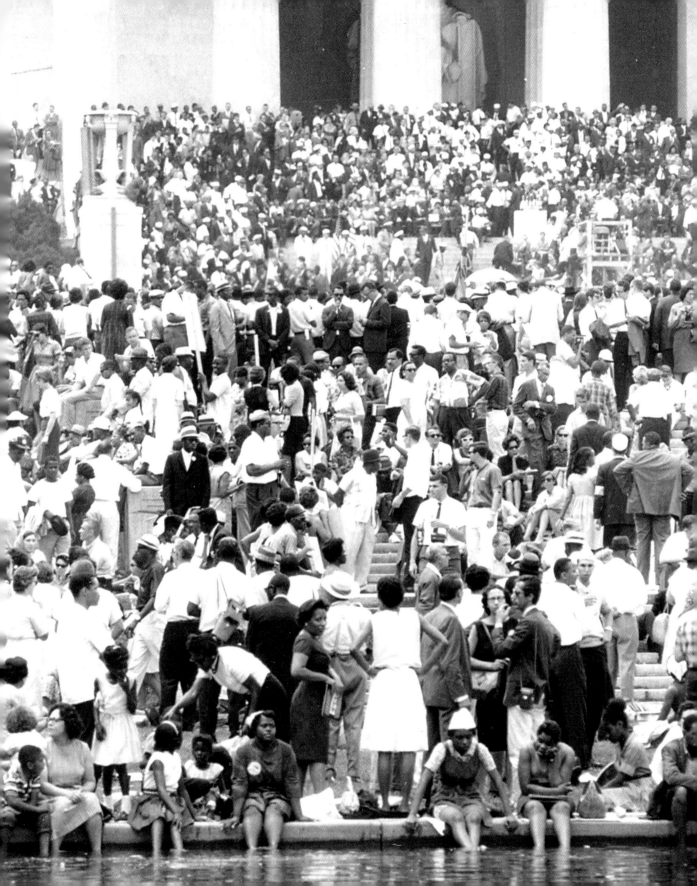

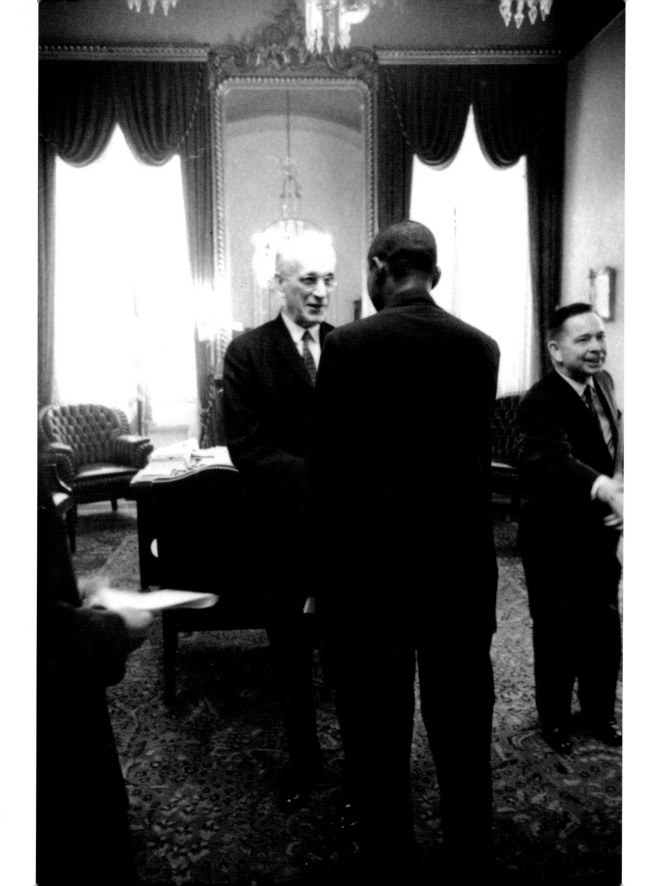

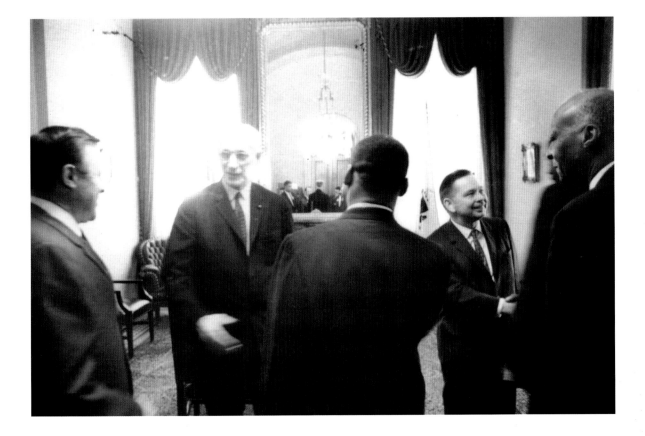

The Big Ten meet Speaker of the House John McCormack and Majority Leader Carl Albert. The Democrats controlled both the House and Senate in 1963–1964. When the civil rights bill originally passed the House in February 1964, 152 Democrats and 138 Republicans voted for it; 96 Democrats and 34 Republicans voted against it. Eighty-seven of the Democratic votes against and 10 of the Republican votes against were from Southern states.

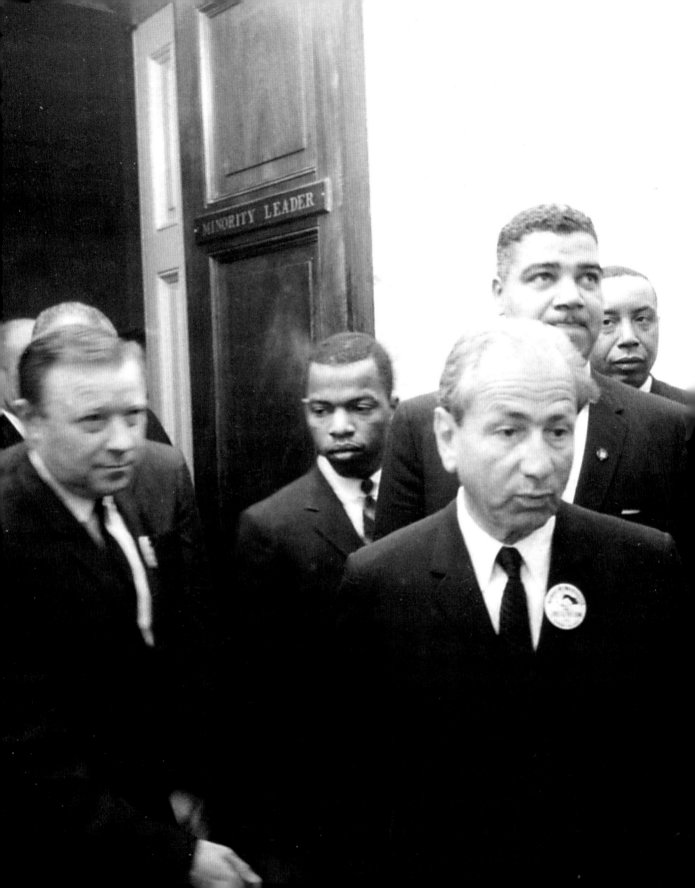

The Big Ten wait in the office of Senate Minority Leader Everett Dirksen (R-Illinois) to press their case for passage of the civil rights bill. Most felt the legislation was not strong enough, but all believed that Congress had to act on behalf of 19 million disenfranchised black Americans. Back, left to right: Walter Reuther, John Lewis, Whitney Young, Floyd McKissick, A. Philip Randolph. Foreground, left to right: Rabbi Joachim Prinz and Martin Luther King, Jr.

Minority Leader Dirksen was essential to securing passage of civil rights legislation. After weeks of filibuster, the Civil Rights Act was signed into law by President Lyndon B. Johnson on July 2, 1964.

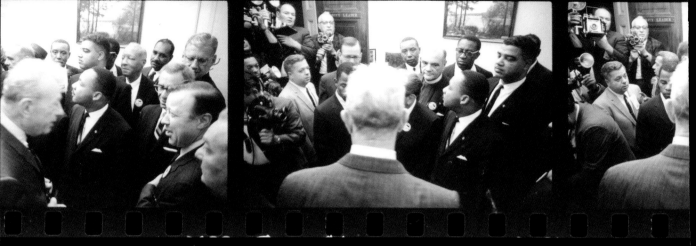

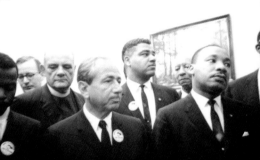

→20

→21

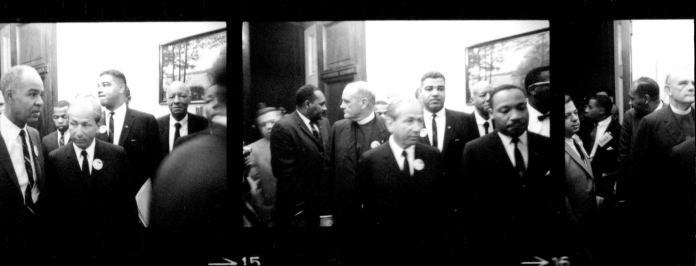

→15

→16

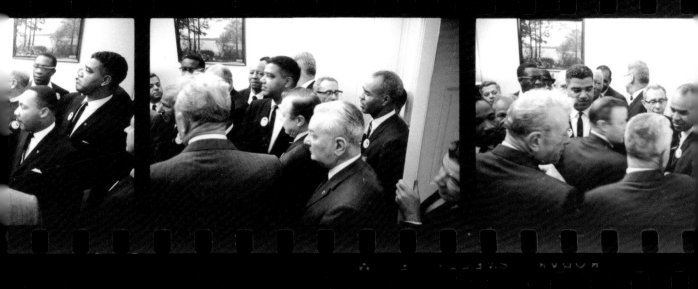

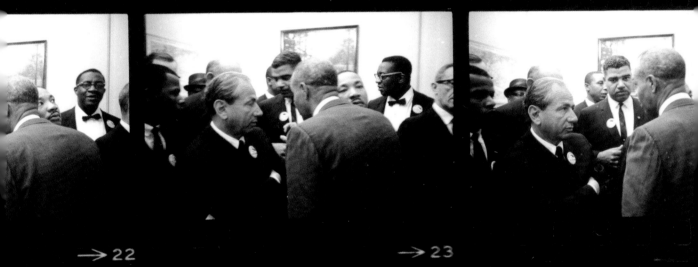

→ 22

→ 23

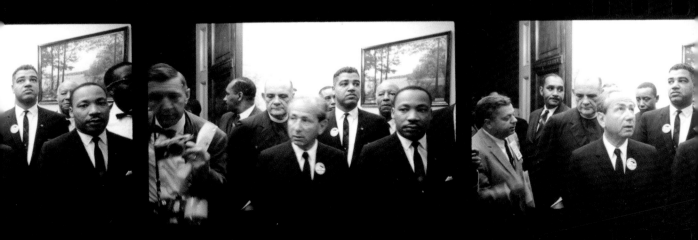

→ 17

→ 18

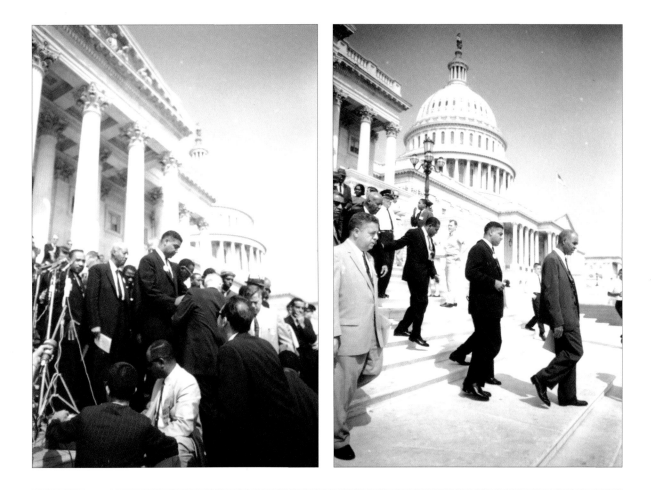

(above) The Big Ten come down the steps on the House side of the east front of the Capitol after meeting with congressional leaders on the morning of the March.

(opposite) A Capitol police officer leads the Big Ten and other civil rights leaders across Statuary Hall, where there were no statues of African Americans. In 1986, a bust of Martin Luther King, Jr., was added, and later a bust of Sojourner Truth, followed by the 2013 unveiling of a statue of Rosa Parks.

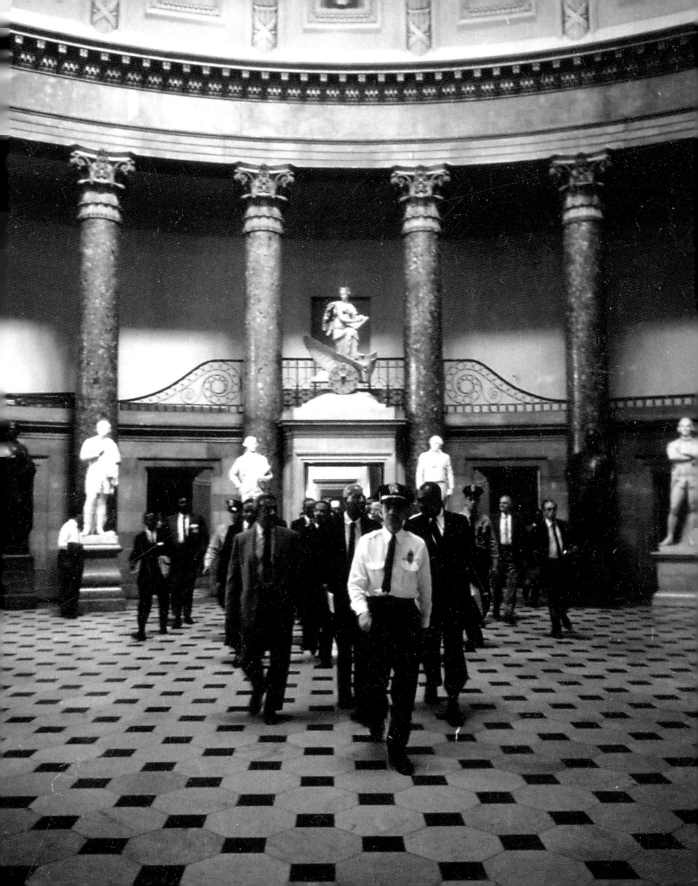

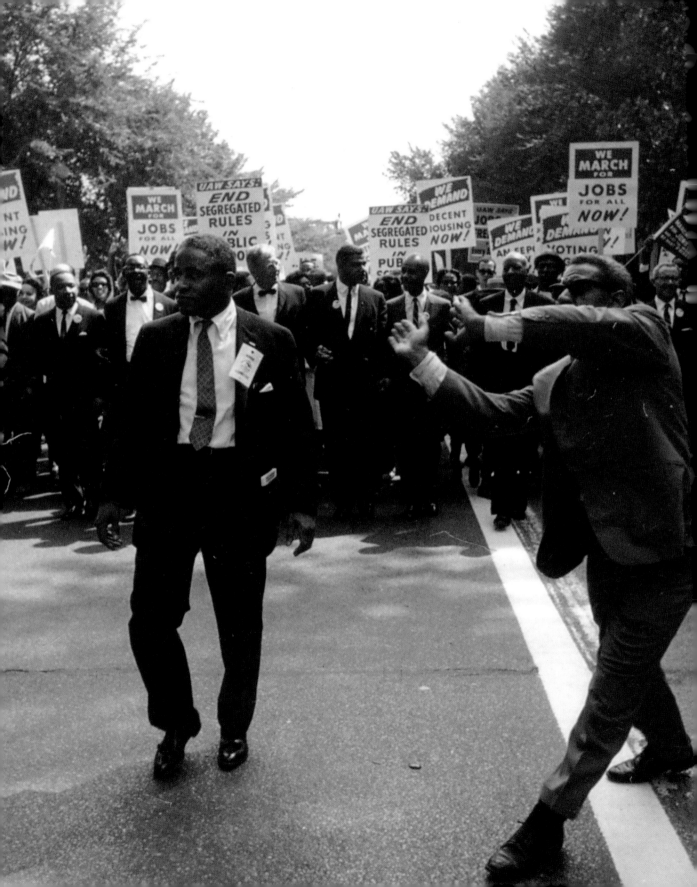

◆ ◆ ◆

Plans had called for the Big Ten to lead the March but the marchers—thousands and thousands of them—surged ahead on their own before the Big Ten arrived, which John Lewis saw as symbolic of the civil rights movement: "A spot was cleared so the photographers could shoot pictures, and some of those photos ran in newspapers the next day as if we were in front of the March," Lewis said. "But we could not even see the front. We came to the Lincoln Memorial, the leaders being pushed along by the people—as it should be."

◆ ◆ ◆

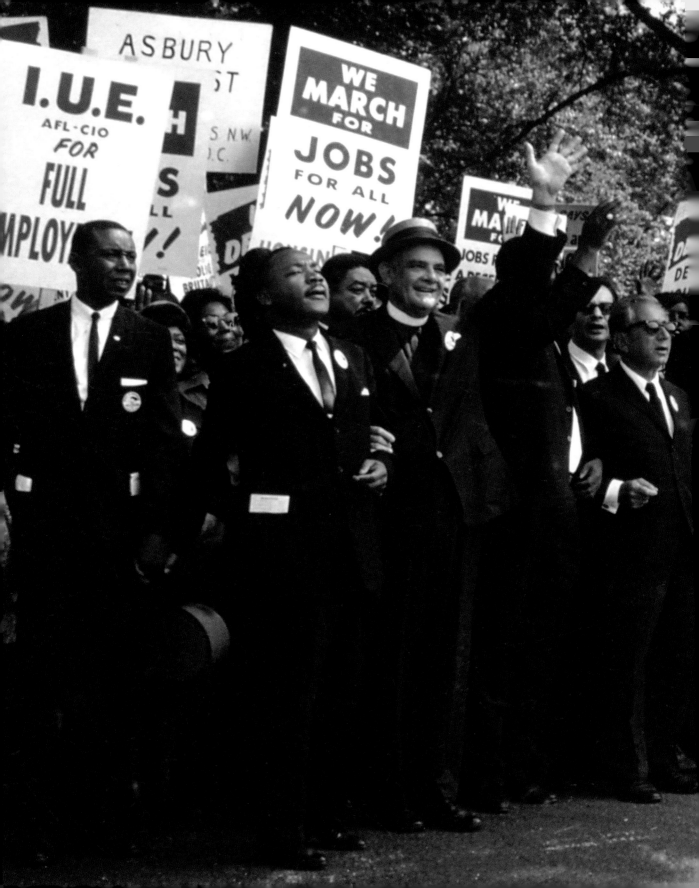

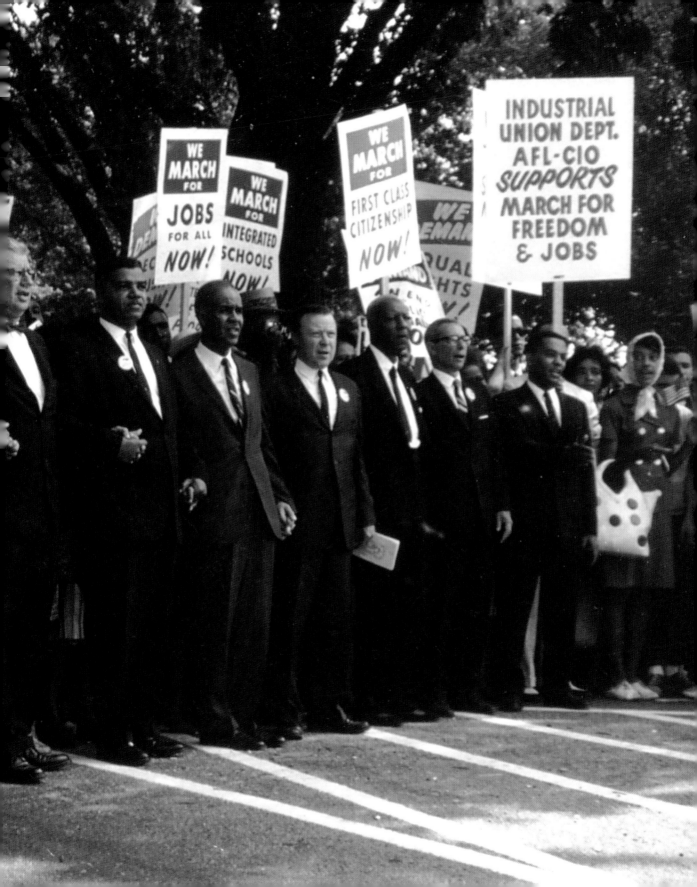

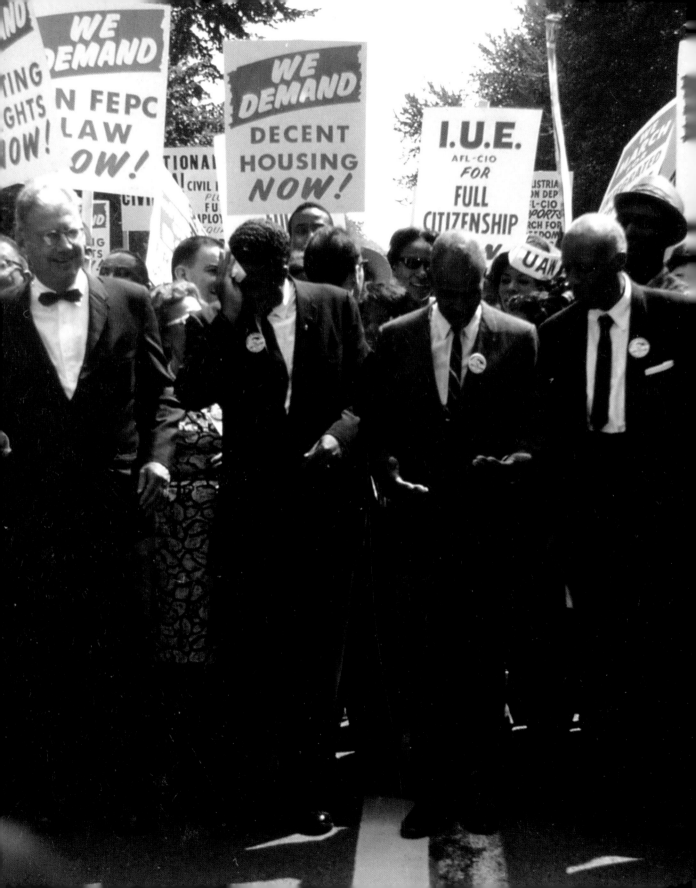

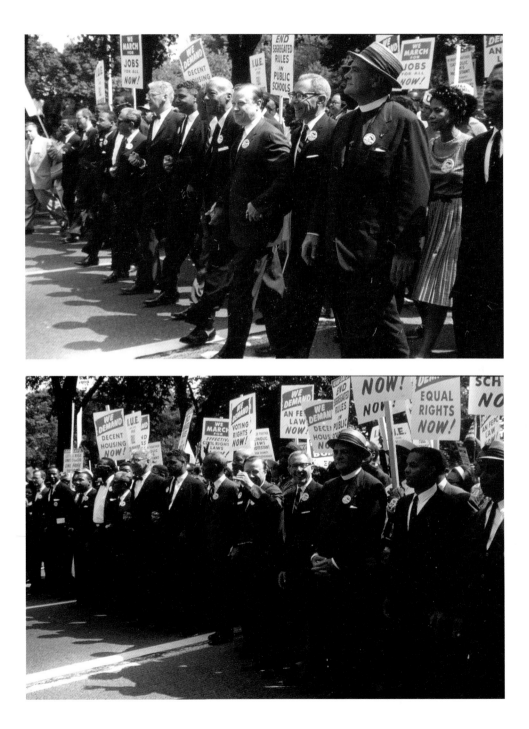

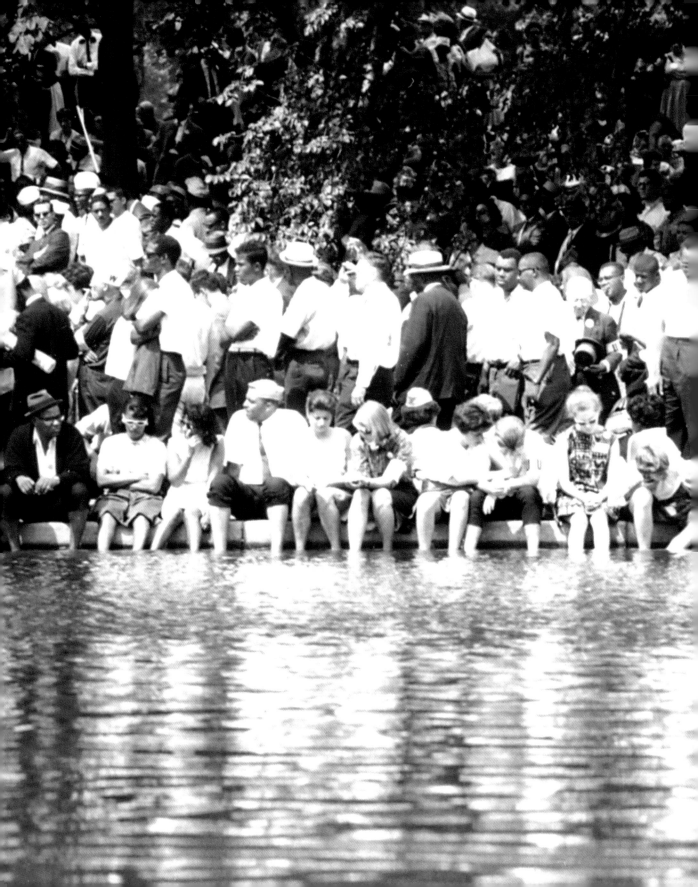

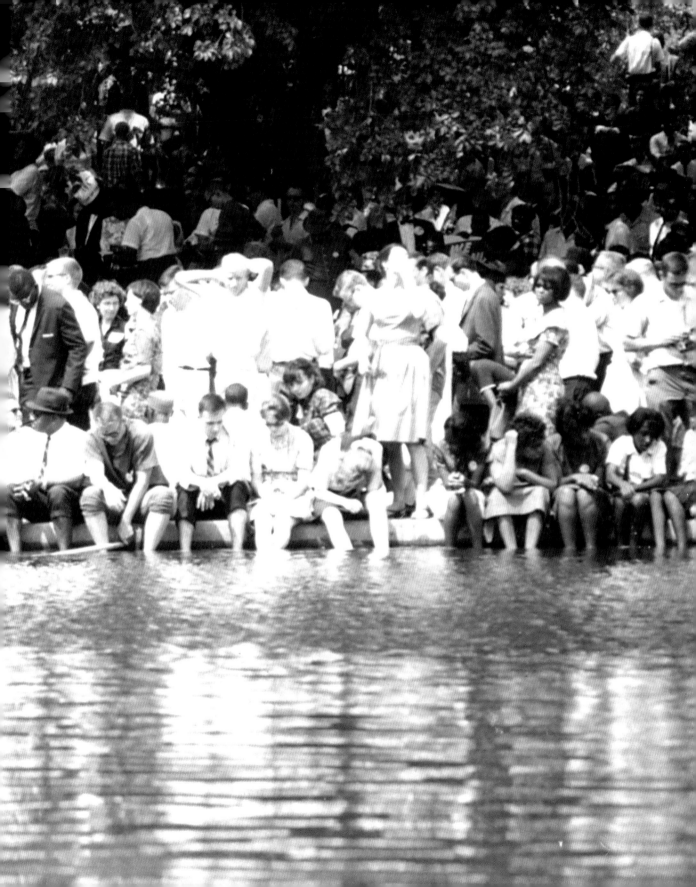

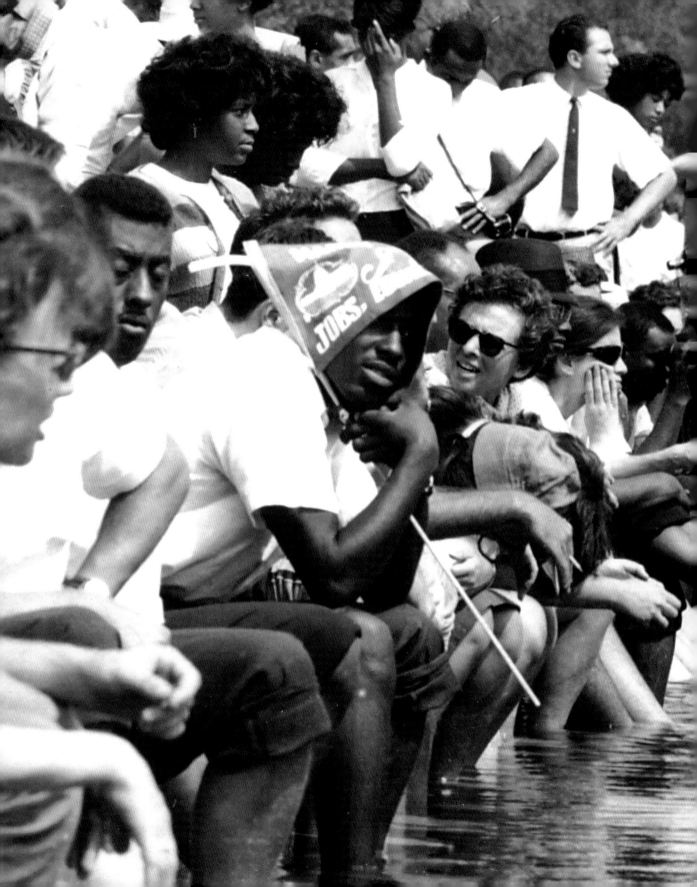

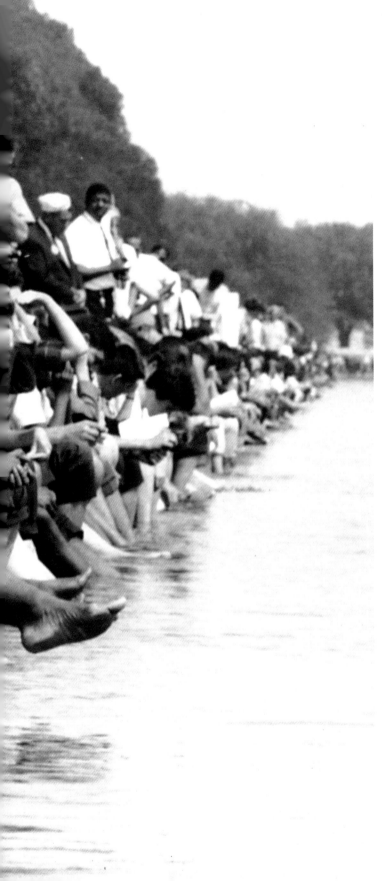
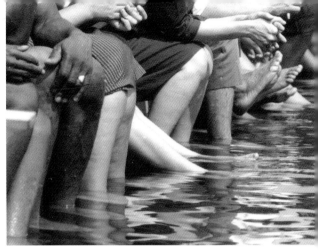
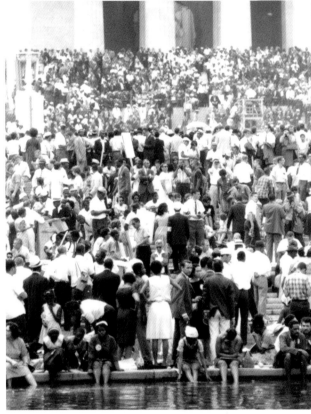
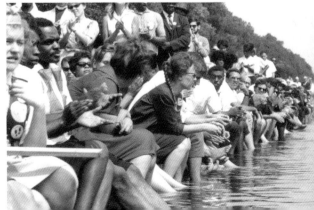

◆　　◆　　◆

Tens of thousands of people gathered twenty deep around the Reflecting Pool, where many sat and dangled their sore marching feet in the mammoth rectangle that holds more than 6 million gallons of water. Listening to the soaring music and the inspiring oratory of the speakers, some marchers later said that sitting on the edge of the Reflecting Pool was almost a religious experience, reminding them of the gospels of Mark, Matthew, and Luke, which describe the disciples of Jesus who gathered at the Sea of Galilee to witness his miracles.

◆　　◆　　◆

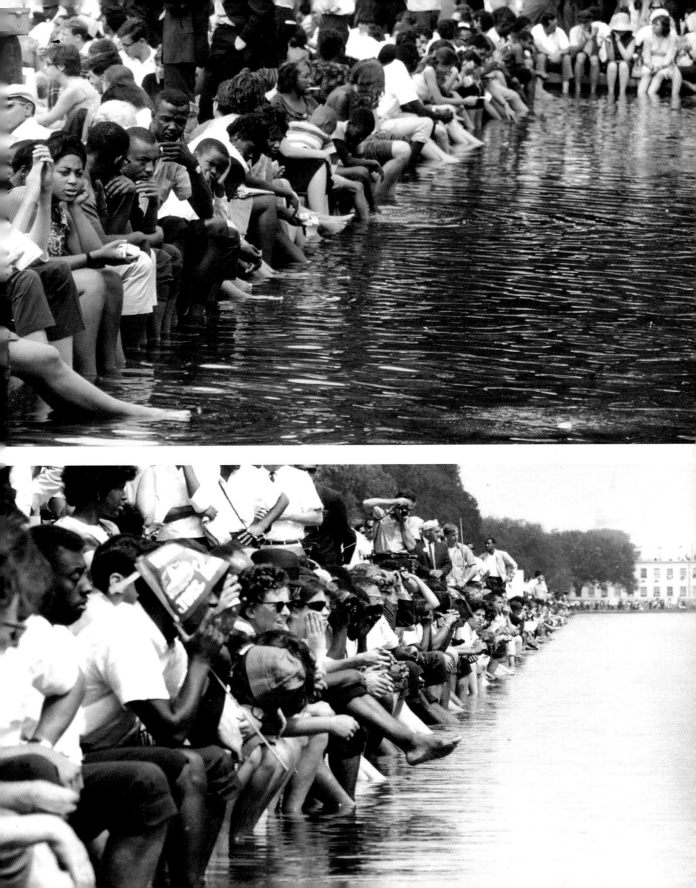

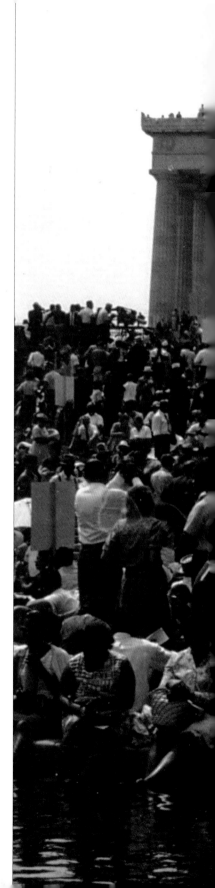

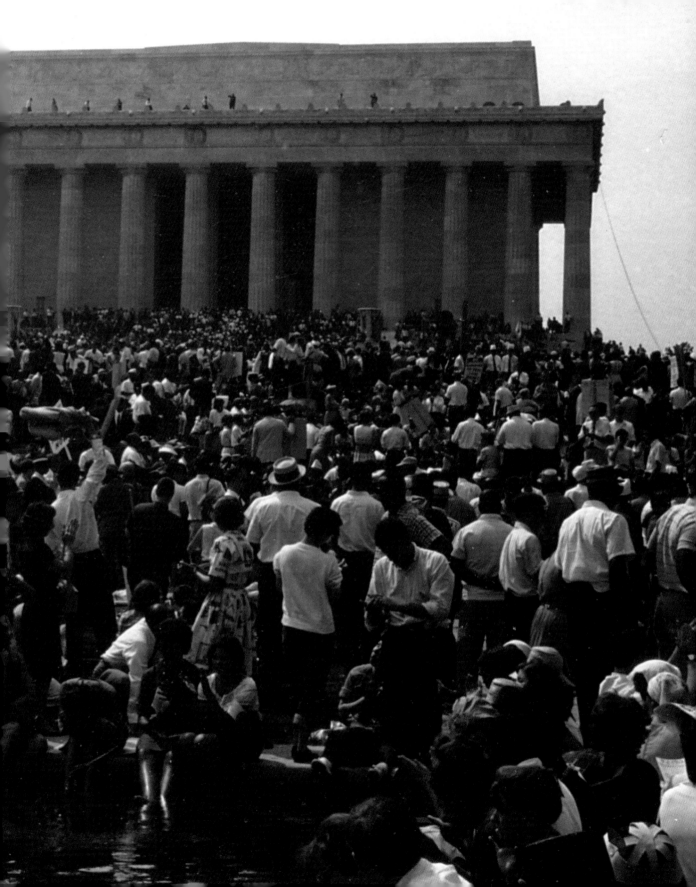

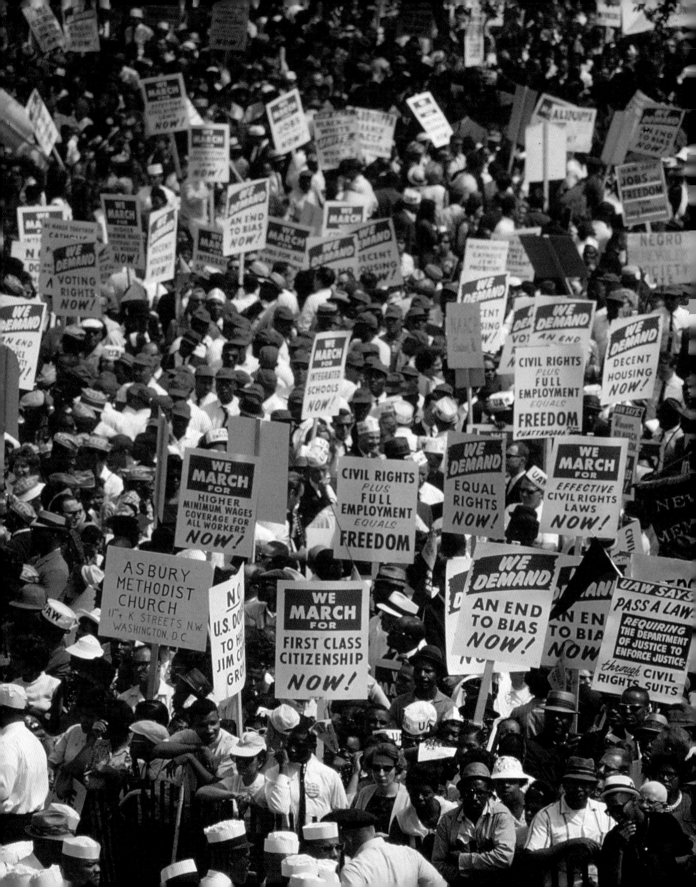

◆ ◆ ◆

Marian Anderson was to open the formal
program with "The Star-Spangled Banner,"
but the renowned contralto could not make
her way through the vast crush of people to
the platform in time, so her place was taken by
Camilla Williams, the first black woman to be
given a role in the New York City Opera.

◆ ◆ ◆

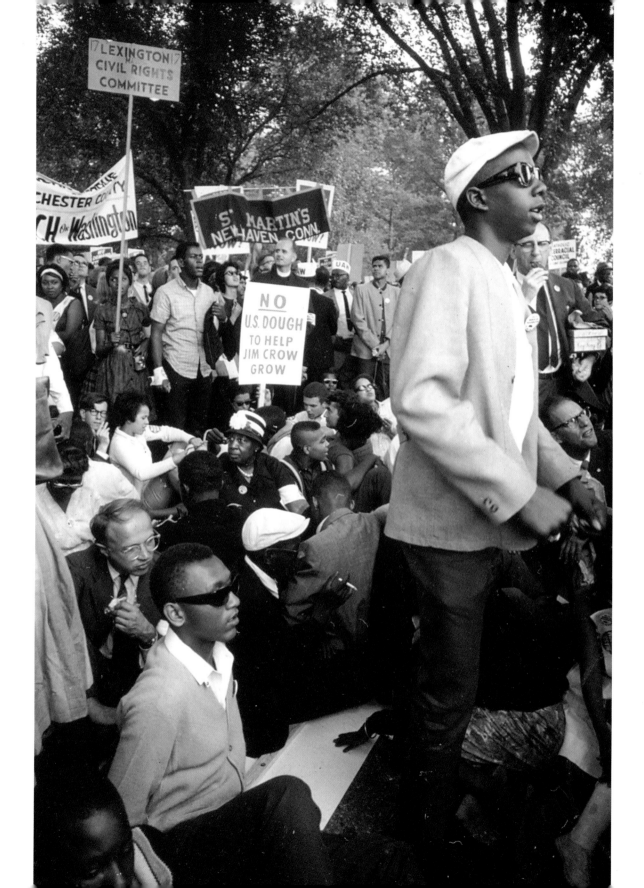

FOLLOWING ARCHBISHOP O'BOYLE'S invocation, A. Philip Randolph, the master of ceremonies, opened the program: "We are not a pressure group; we are not an organization or a group of organizations; we are not a mob. We are the advance guard of a massive moral revolution for jobs and freedom."

When Marian Anderson finally reached the platform, she moved the masses with her deep and solemn voice, singing "He's Got the Whole World in His Hands." Listening to her fill the skies, one could actually believe that He really did have "you and me, brother, in His hands."

Interspersed with the soaring music were the seven-minute speeches from each of the Big Ten. Each in his own way delivered powerful messages about the black struggle since Emancipation, and each stressed with emotion (and some with harsh words) that no one is free until the Negro is free.

The trumpet for freedom was sounded by Floyd McKissick.

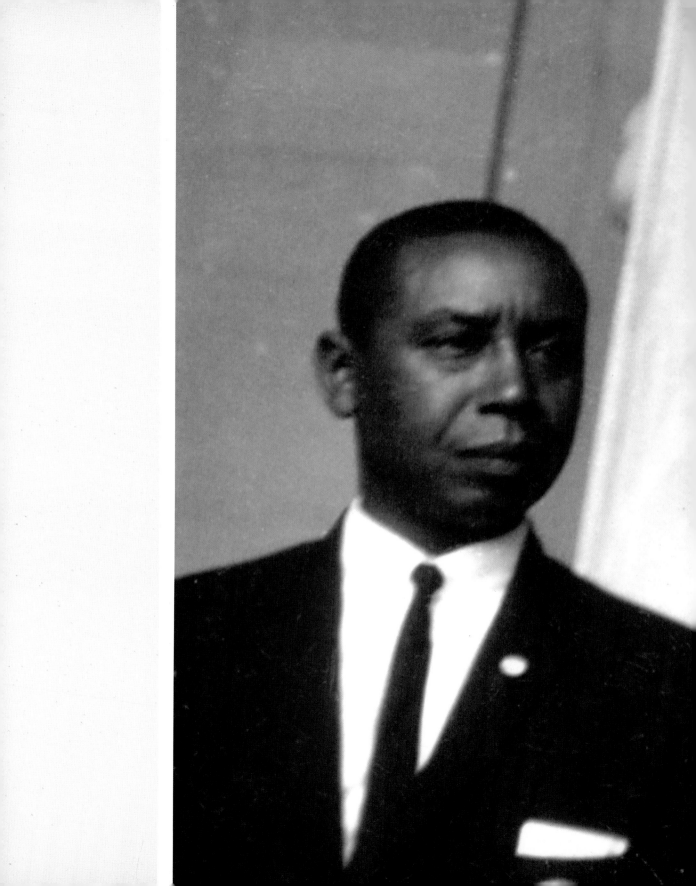

Floyd McKissick (1922–1991) was National Chairman of the Congress of Racial Equality. He represented CORE president James Farmer during the March on Washington because Farmer chose to remain in jail in Louisiana with those who had been arrested with him for demonstrating.

McKissick joined the civil rights movement as a twelve-year-old when picketers from his hometown of Asheville, North Carolina, demonstrated at the state capital in Raleigh to ask for accreditation for the Negro law school at North Carolina College. He graduated from the University of North Carolina Law School, where he became the first African American to attend after winning a lawsuit to force his admission. His lawyer was NAACP attorney Thurgood Marshall, later to become the first African American Justice of the United States Supreme Court.

James Farmer (1920–1999) founded CORE in 1942 with a group of students from the University of Chicago. The purpose of the interracial organization was to work for an end to racial segregation using the non-violent methods of Mahatma Gandhi. Farmer led the Freedom Rides of 1961 and served as Assistant Secretary under President Nixon in the Department of Health, Education and Welfare to initiate affirmative action in hiring practices. Unhappy with the Nixon administration, he resigned, became a history professor at Mary Washington College in Fredricksburg, Virginia, and received the Medal of Freedom in 1998 from President Clinton.

From a South Louisiana parish jail I salute the March on Washington for Jobs and Freedom. Two hundred and thirty-two Freedom Fighters here with me also send their greetings. I wanted to be with you with all my heart for this great day. I cannot come out of jail while they are still in, for their crime was the same as mine, demanding freedom now....

Some of us may die like...Medgar Evers but our war is for life, not for death. And we will not stop our demand for our freedom now. We will not slow down. We will not stop our militant, peaceful demonstration. We will not come off of the streets until we can work at a job befitting of our skills in any place in the land. We will not stop our marching feet until our kids have enough to eat and their minds can study a wide range without being cramped in Jim Crow schools....

The tear gas and the electric cattle prods of Plaquemine, Louisiana, like the fire hoses and dogs of Birmingham, are

giving to the world a tired and ugly message of terror and brutality and hate. Theirs is a message of pitiful hopelessness from little and unimaginative men to a world that fears for its life. It is not they to whom the world is listening today, it is to American Negroes....

Until we live wherever we choose and can eat and play with no closed doors blocking our way, we will not stop the dogs that are biting us in the South and stop the rats biting in the North. We will not stop until the heavy weight of centuries of oppression is removed from our backs and like proud men everywhere when we can stand tall together again. That is Jim Farmer's message. May I add that may this day be a day of beginning for us, but may we rededicate ourselves to the most effective weapon that we have and that we have achieved success by? That is the weapon of direct nonviolent action. Go back to your home, do not be misled, and carry on the fight to free all Americans black and white.

◆　　◆　　◆

By the time John Lewis approached the microphone, some of his original text had been softened, but not his passion:

We march today for jobs and freedom, but we have nothing to be proud of, for hundreds and thousands of our brothers are not here—for they are receiving starvation wages or no wages at all. While we stand here there are sharecroppers in the Delta of Mississippi who are out in the field working for less than $3.00 a day, twelve hours a day. While we stand here there are students in jail on trumped-up charges. What about the three young men in Americus, Georgia, who face the death penalty for engaging in peaceful protest?

My friends, let us not forget that we are involved in a serious social revolution. By and large American politics is dominated by politicians who build their career on immoral compromises and ally themselves with open forms of political, economic, and social exploitation.

There are exceptions, of course, and we salute those, but what political leader can stand up and say, "My party is a par-

ty of principles?" For the party of Kennedy is also the party of Eastland. The party of Javits is also the party of Goldwater. Where is our party? Where is the political party that will make it unnecessary to march on Washington?

I appeal to all of you to get in this great revolution that is sweeping this nation. Get in and stay in the streets of every city...until true freedom comes. If we do not get meaningful legislation out of this Congress the time will come when we will not confine our marching to Washington. But we will march with the spirit of love and with the spirit of dignity that we have shown here today. By the forces of our demands, our determination and our numbers we shall shatter the segregated South into a thousand pieces and put them together in the image of democracy. We must say, "Wake up, America. Wake up," for we cannot stop and we will not and cannot be patient.

◆　　◆　　◆

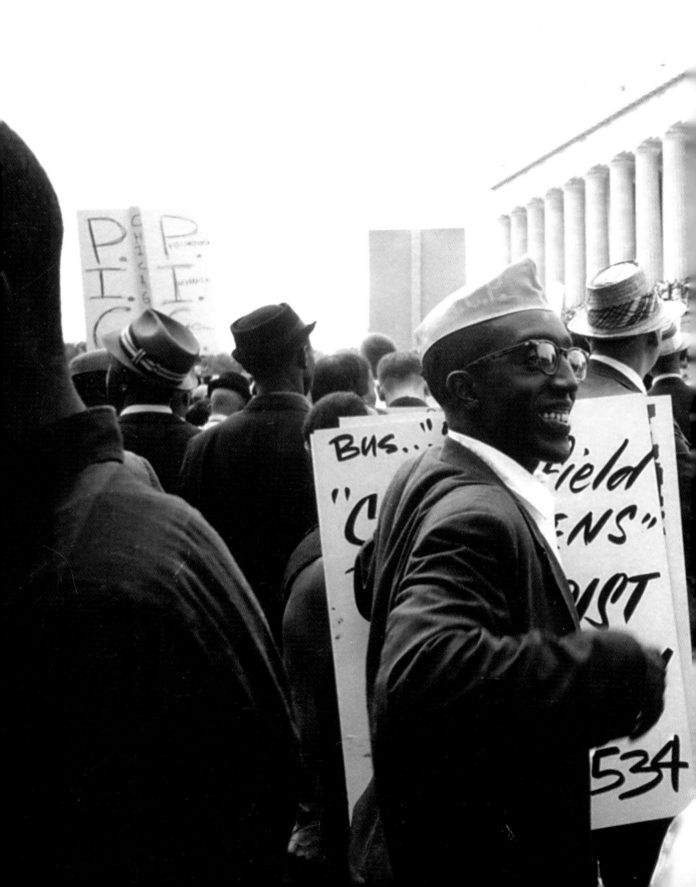

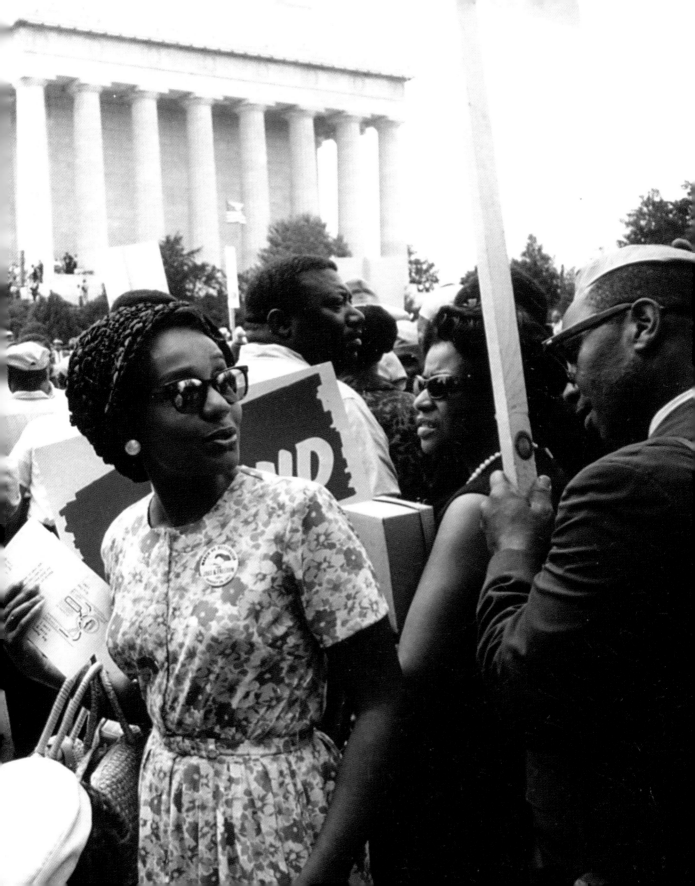

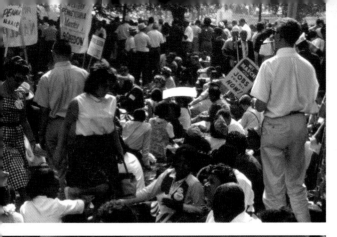

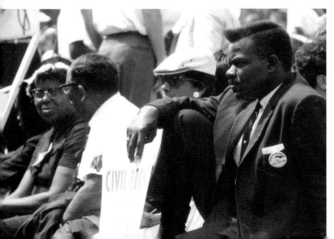

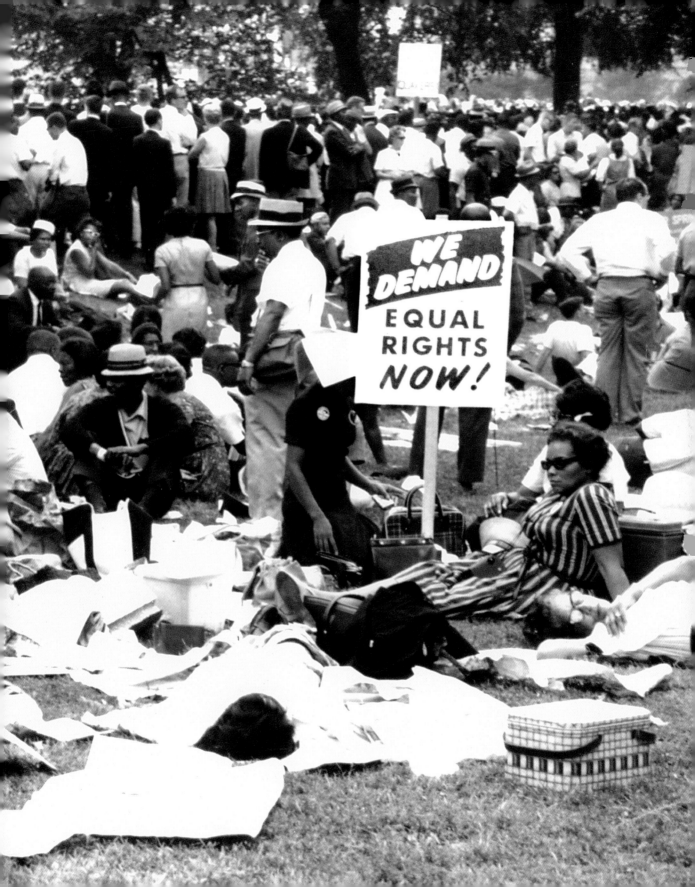

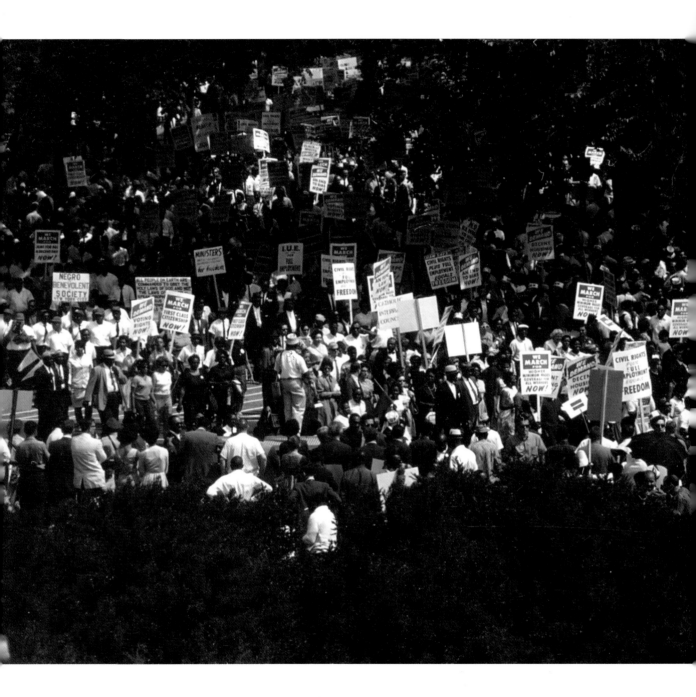

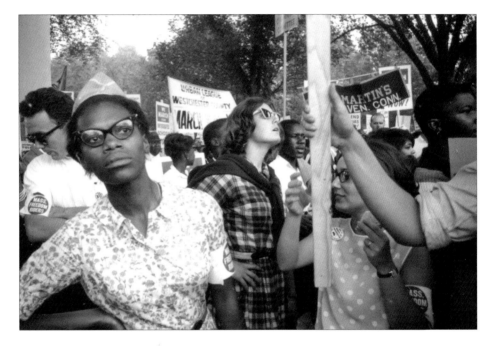

The racial diversity of the marchers—black and white—can be seen in every photograph and was a testament to the commitment for civil rights legislation, which reached its glorious peak with the March on Washington on August 28, 1963. This massive demonstration of peaceful participants sent a message to Congress that the time had arrived to make Martin Luther King's dream come true for everyone.

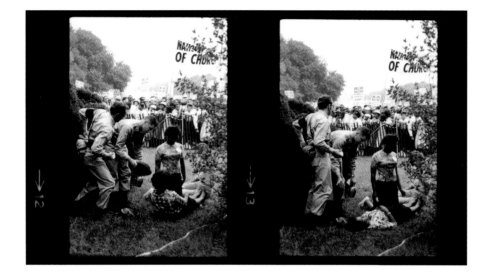

IN THE MIDDLE OF THAT HOT
afternoon, the crowds waved their placards and shouted "Amen, brother.
Amen." Some began showing the strains of the day and were overcome
with dehydration and heat prostration. They were carried by March
marshals to on-site medical units that had been arranged for first-aid emergen-
cies. Many people, exhausted by sheer ecstasy, were heading to the shuttle
buses for relief from the heat, when they heard the organ pipes herald the
majestic appearance of Mahalia Jackson, the most renowned gospel singer of
the era. Her strong and stirring voice seemed to reverberate from the marble
steps of the Lincoln Memorial to the marble steps of Congress as she sang of
the slave experience: "I been 'buked and I been scorned." The applause rolled
like thunder.

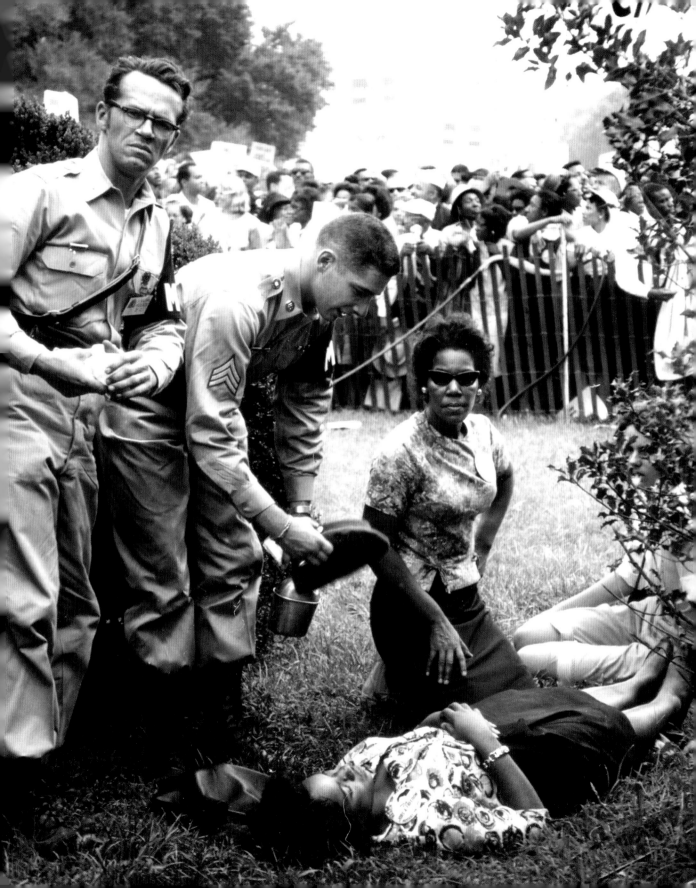

♦ ♦ ♦

After Rabbi Joachim Prinz had spoken,
Randolph rose to introduce the day's
last speaker, "a philosopher of a nonvio-
lent system of behavior seeking to bring
about social change for the advancement
of justice and freedom and human
dignity. I have the pleasure to present to
you Dr. Martin Luther King, Jr., the
moral leader of the nation."

♦ ♦ ♦

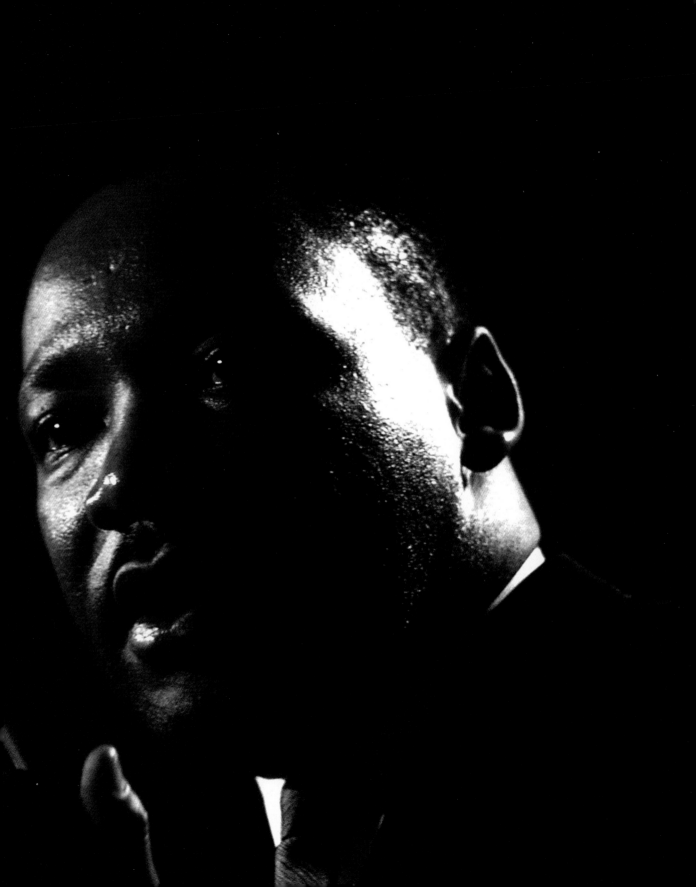

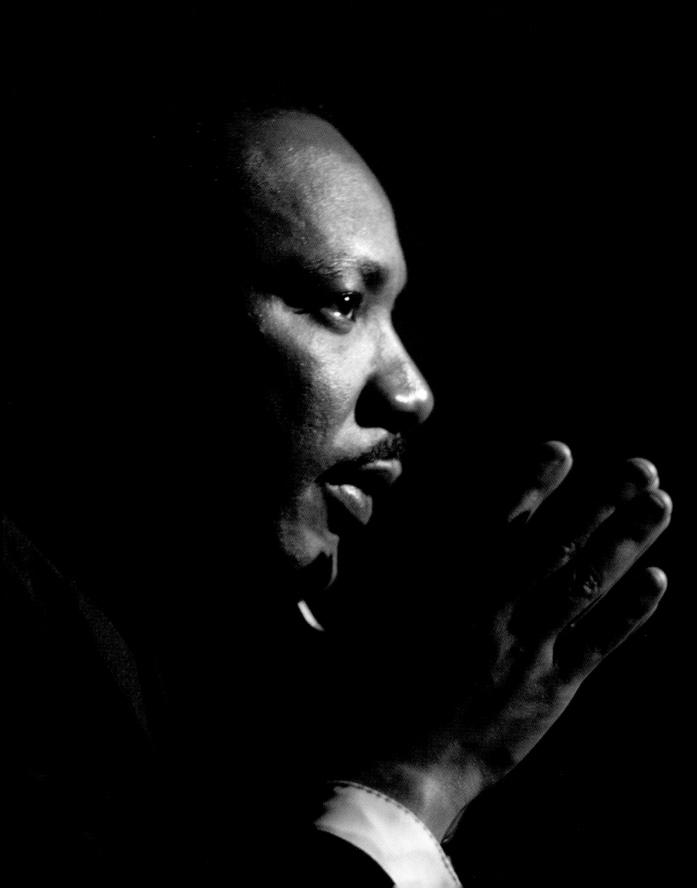

Martin Luther King, Jr. (1929–1968), received his Ph.D. from Boston University in 1955 and moved to Montgomery, Alabama, to organize a bus boycott. He founded the Southern Christian Leadership Conference, and moved from Montgomery to Atlanta, where he was co-pastor with his father of the Ebenezer Baptist Church. He originated the strategy of non-violence within the activist civil rights community, which earned him the Nobel Peace Prize in 1964.

His "I Have a Dream" speech at the March on Washington in 1963 enshrined him as the most charismatic civil rights leader of the twentieth century. He dedicated his life, his international prestige, and his stirring oratory to pursuing equal rights for the dispossessed. Even as he recognized the growing frustration experienced by blacks, whose nonviolent protests were met with increasing violence, he reaffirmed his commitment to precepts of peace.

On April 3, 1968, he addressed a rally in Memphis, Tennessee, and talked of the threats to his life. He urged his followers to continue the nonviolent struggle no matter what happened to him. The next night, as he stood on the balcony of the Lorraine Hotel, he was assassinated. The next day a national wave of rioting and looting broke out in 110 cities. In Washington, D.C., twelve people were killed, over a thousand injured, and 6,100 arrested. Estimated damage to homes and stores exceeded $27 million.

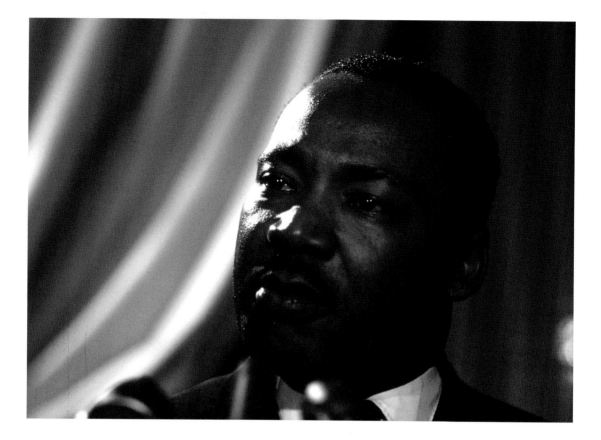

A WAVE OF THUNDEROUS APPLAUSE rolled across the Mall as King walked to the foot of the Lincoln Memorial. He had been up most of the night writing his speech, which was to be the capstone of this glorious day. He smiled at the mass of humanity before him, a little nervous at first because he had never addressed a crowd of 250,000 people, all of whom anticipated oratory of unparalleled inspiration. Women waved white lace hankies; men stomped and cheered and clapped. For one full minute the speaker was not allowed to speak. Finally, a hush fell, and he began.

I am happy to join with you today in what will go down in history as the greatest demonstration for freedom in the history of our nation.

Five score years ago a great American in whose symbolic shadow we stand today signed the Emancipation Proclamation. This momentous decree came as a great beacon light of hope to millions of Negro slaves, who had been seared in the flames of withering injustice. It came as a joyous daybreak to end the long night of their captivity. But 100 years later the Negro still is not free....

◆　　◆　　◆

In a sense we've come to our nation's capital to cash a check. When the architects of our republic wrote the magnificent words of the Constitution and the Declaration of Independence, they were signing a promissory note to which every American was to fall heir. This note was a promise that all men, yes, black men as well as white men, would be guaranteed the unalienable rights of life, liberty, and the pursuit of happiness. It is obvious today that America has defaulted on this promissory note insofar as her citizens of color are concerned. Instead of honoring this sacred obligation, America has given the Negro people a bad check, a check which has come back marked "insufficient funds."

But we refuse to believe that the bank of justice is bankrupt. We refuse to believe that there are insufficient funds in the great vaults of opportunity of this nation. And so we've come to cash this check—a check that will give us upon demand the riches of freedom and the security of justice.

We have also come to this hallowed spot to remind America of the fierce urgency of now. This is no time to engage in the

luxury of cooling off or to take the tranquilizing drug of gradualism. Now is the time to make real the promise of democracy. Now is the time to rise from the dark and desolate valley of segregation to the sunlit path of racial justice. Now is the time to lift our nation from the quicksands of racial injustice to the solid rock of brotherhood.

Now is the time to make justice a reality for all God's children....

I am not unmindful that some of you have come here out of great trials and tribulation. Some of you have come fresh from narrow jail cells. Some of you have come from areas where your quest for freedom left you battered by the storms of persecution and staggered by the winds of police brutality. You have been the veterans of creative suffering.

Continue to work with the faith that unearned suffering is redemptive. Go back to Mississippi, go back to Alabama, go back to South Carolina, go back to Georgia, go back to Louisiana, go back to the slums and ghettos of our northern cities, knowing that somehow this situation can and will be changed.

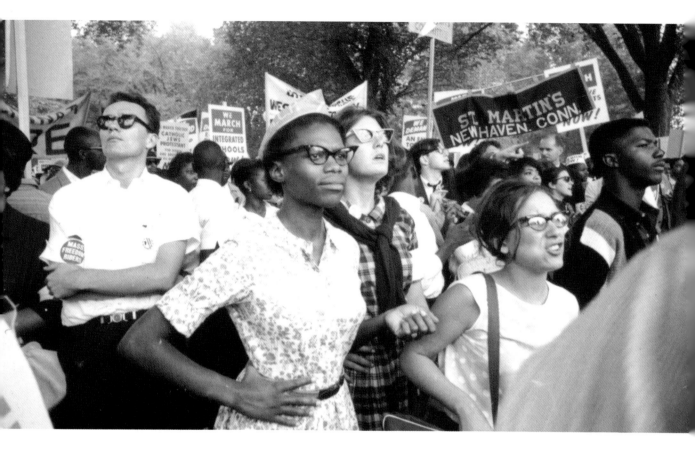

KING DEALT WITH THE REALITY

of blacks' lack of freedom, but he urged them not "to wallow in the valley of despair." He cautioned them against bitterness and hatred and encouraged them instead "to hew out of the mountain of despair a stone of hope."

Lifting his voice with drama he reminded everyone of the shame that had brought them together on this day.

Aroused by the soaring rhetoric of this thirty-four-year-old preacher, the crowd roared its admiration and fell quiet when he paused for a moment.

"Tell them about the dream, Martin," shouted Mahalia Jackson. "The dream."

Weeks before, King had traveled to Detroit with Walter Reuther and others to lead 125,000 people down Woodward Avenue in a march to end segregation, and there King mentioned his dream: "I have a dream this afternoon, that one day right here in Detroit, Negroes will be able to buy a house or rent a house anywhere that their money will carry them and they will be able to get a job."

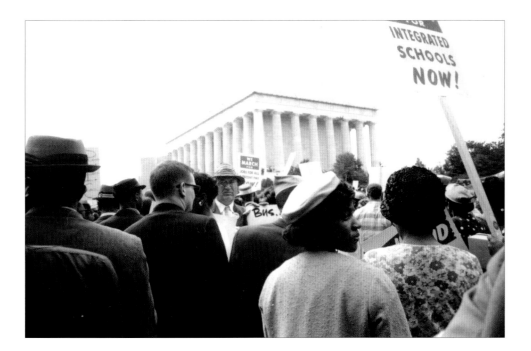

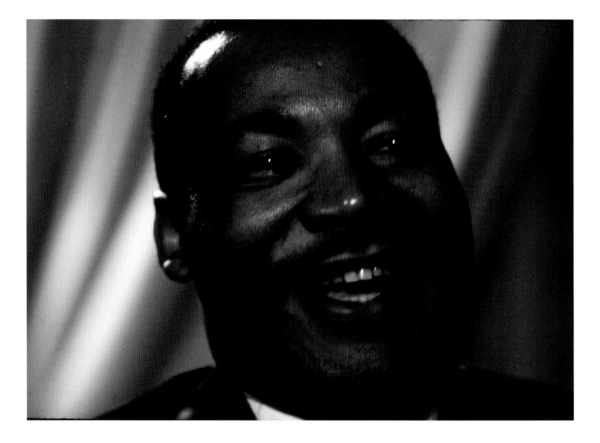

Now, in front of the largest crowd ever gathered in Washington, D.C., Dr. King departed from his prepared text to share his dream, which expanded from Detroit to embrace the entire country in order to open white minds and lift up black hearts. Dr. King had traveled 275,000 miles the year of the March and delivered 350 speeches, trying to make white America understand the desperation of black America.

Even though we face the difficulties of today and tomorrow, I still have a dream.... It is a dream chiefly rooted in the American dream.

I have a dream that one day this nation will rise up and live out the true meaning of its creed: "We hold these truths to be self-evident, that all men are created equal."

I have a dream...

The vast throng of humanity roared.

...that one day on the red hills of Georgia, the sons of former slaves and the sons of former slave-owners will be able to sit together at the table of brotherhood.

I have a dream...

Again the crowd roared.

...that one day even the State of Mississippi, a state sweltering with the heat of injustice, sweltering with the heat of oppression, will be transformed into an oasis of freedom and justice. I have a dream...

The crowd roared.

 ...that my four little children will one day live in a nation where they will not be judged by the color of their skin but by the content of their character.

The soaring rhetoric of his dream penetrated the walls of the White House, where the President was watching on television. He, too, seemed to be transfixed. "He's good," said Kennedy. "He's damn good."

I have a dream today...

The crowd roared.

 ...that one day every valley shall be exalted, every hill and mountain shall be made low, the rough places will be made plain and the crooked places will be made straight, and the glory of the Lord shall be revealed and all flesh shall see it together.

In the rising cadence of a spellbinder like no other, Dr. King told America that if it was to become a great nation, it must make the dream of freedom come true for its black citizens.

And when this happens, when we allow freedom to ring, when we let it ring from every village and every hamlet, from every state and every city, we will be able to speed up that day when all of God's children, black men and white men, Jews and Gentiles, Protestants and Catholics, will be able to join hands and sing in the words of the old Negro spiritual: Free at last! Free at last! Thank God Almighty, we are free at last.

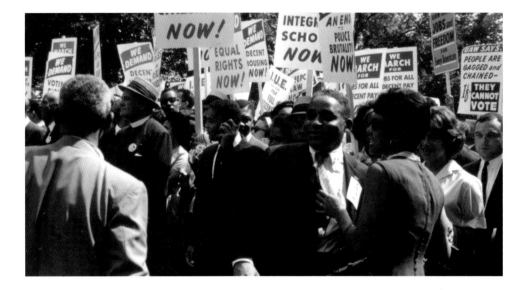

F EELING BLESSED BY KING'S WORDS
and vision, waves of people held hands, swaying and singing "We
Shall Overcome."

A few weeks later Martin Luther King reflected on why he de-
cided to leave his written text and extemporize to the nation about his dream: "I
started out reading the speech, and I read it down to a point, and just all of a
sudden, I decided…the audience response was wonderful that day, you know…and
all of a sudden this thing came to me that I have used…I'd used many times before,
that thing about 'I have a dream'…and I just felt that I wanted to use it here. I
don't know why. I hadn't thought about it before the speech."

Minutes after Martin Luther King had mesmerized the country with his
dream, A. Philip Randolph concluded the March. In a rich voice that boomed
over the speakers, he beseeched everyone to stand to take a public pledge "for
complete commitment to the struggle for jobs and freedom" and "to carry the
message to friends and neighbors back home and arouse them to an equal com-
mitment and an equal effort."

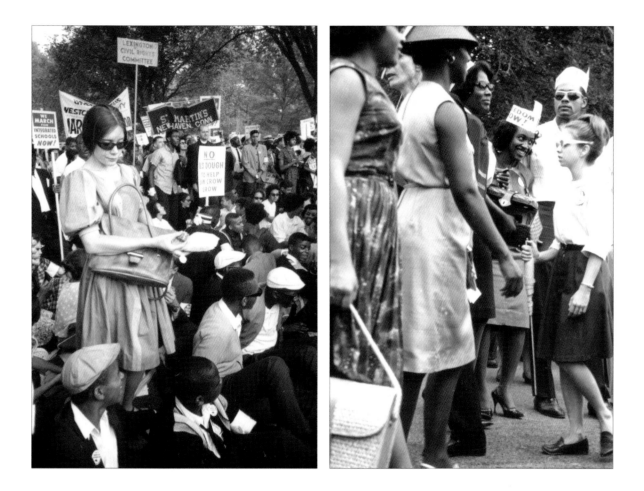

Having pledged themselves to continue the movement, the tired marchers walked toward their buses and were well on their way out of town before sunset. The Big Ten were driven to the White House, where the President greeted them in the Oval Office with relief and respect. He said the March had advanced the cause of America's Negroes and made a contribution to all mankind: "One cannot help but be impressed with the deep fervor and the quiet dignity that characterizes the thousands who have gathered here today."

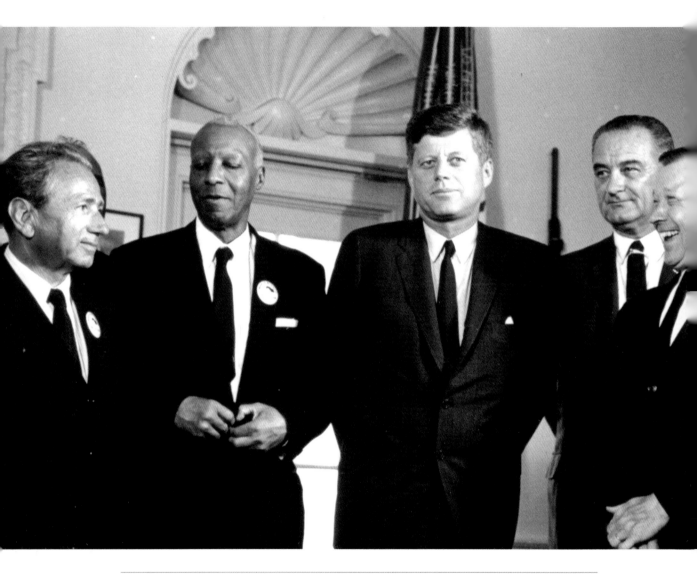

President Kennedy meets with leaders of the March on Washington at the White House. Left to right: Rabbi Joachim Prinz; A. Philip Randolph; President Kennedy; Vice President Lyndon Johnson; Walter Reuther, laughing about a line in his speech that chided the administration for not proposing stronger civil rights legislation.

J FK GREETED DR. KING, SHAKING
his hand and saying, "I have a dream."

"The President was bubbling over with the success of the event," Roy Wilkins recalled in an oral history. "The way it had gone off...and when he found that we hadn't had an opportunity to get luncheon...he sent downstairs in the dining room, which is in the White House, and brought up sandwiches and milk and tea and coffee for us.

"The President you could see was very relieved after all the predictions locally of the Washington merchants and the Washington people that the capital was going to be invaded by a horde of rowdies and vigilantes. Some of the people who ran businesses closed their businesses and sent their employees home, gave them the day off, and told them to lock themselves in their homes because the Negroes would be here and would tear up the town. Of course, nothing like that happened."

During the hour the President spent with the Big Ten there was a good bit of jocularity. At one point King asked the President if he had heard Walter Reuther's speech.

"No, I did not hear Walter," Kennedy said with a grin, "but I have heard Walter."

The President was well aware of the union leader's criticism of his civil rights bill for not being strong enough. Reuther, a lifelong activist, had been badly beaten in union strikes during the 1950s and was now in the forefront of the civil rights movement, always pushing the administration to do more. Renowned as an orator, Reuther told the President, "I had a couple of new punch lines today." In his speech at the Lincoln Memorial he had jabbed Kennedy's "Ich bin ein Berliner" speech, saying, "We can't defend freedom in Berlin so long as we deny freedom in Birmingham."

Despite the jibes here and there, the President told reporters that he was edified by the day's speeches, the crowds—the entire event. "The nation can be properly proud of this march," he said.

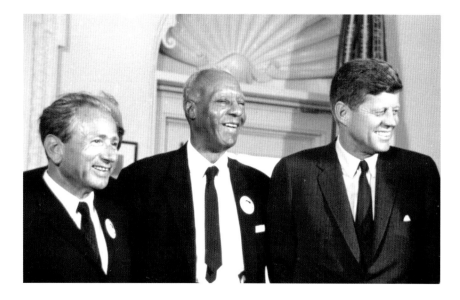

(above) **Rabbi Prinz, A. Philip Randolph, and President Kennedy** share a moment of levity at the White House after the March. Most of the Big Ten reported later the palpable sense of relief that everyone felt, especially the President, over the day's events. Despite all the dire predictions, the marchers had shown that more than 250,000 people could assemble in peace and harmony in the nation's capital to petition their government to address civil rights, the most divisive issue of the time.

(right) **Left to right: Secretary of Labor Willard Wirtz; Floyd McKissick, Congress of Racial Equality; Mathew Ahmann, executive director of the National Catholic Conference for Interracial Justice; Whitney Young, executive director of the National Urban League; Martin Luther King, Jr., founder and president, Southern Christian Leadership Conference; John Lewis, chairman, Student Nonviolent Coordinating Committee; Rabbi Joachim Prinz, president, American Jewish Congress; Reverend Eugene Carson Blake, president, National Council of Churches; A. Philip Randolph, president, Brotherhood of Sleeping Car Porters; President Kennedy; Vice President Johnson; Walter Reuther, president, United Auto Workers; Roy Wilkins, executive secretary, National Association for the Advancement of Colored People.**

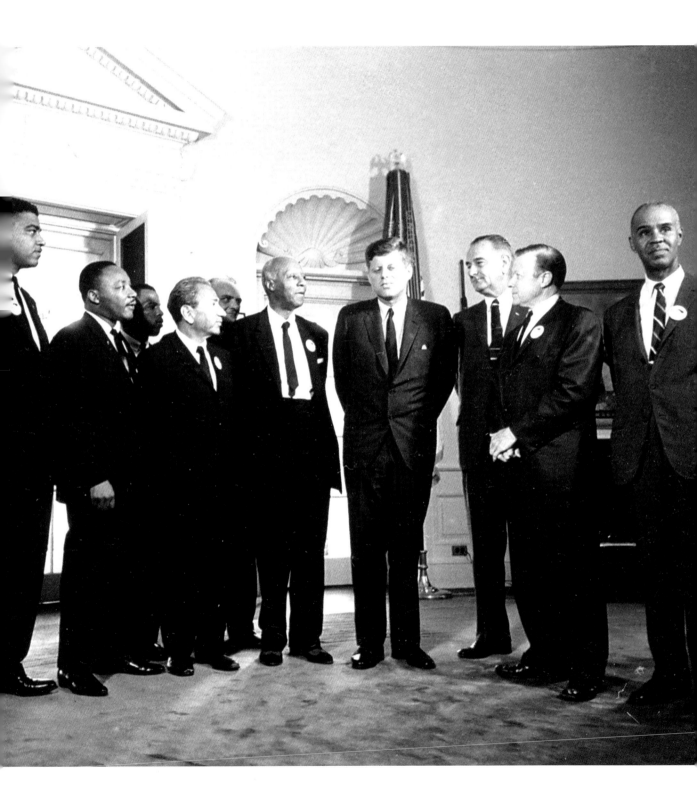

$50,000 PLACED ON HEAD OF BOMBE

(Story in Column)

Stick of dynamite stirs city

(PHOTO ON PAGE 3)
BIRMINGHAM, Ala. — City officials quickly slapped a $50,000 bounty on the head of persons responsible for the Tuesday - night bombing at the home of civil rights attorney Arthur B. Shores. The incident pushed racial tensions here to a new high.

The blast, believed caused by a stick of dynamite, occurred about 9:30 p.m. It nearly destroyed the house's recreation room and heavily damaged the kitchen. Also hard - hit was the garage and the Shores' two automobiles.

The attorney, who handled the University of Alabama integration case, was at home alone when the explosion occurred. He was reported unhurt but shaken. His wife and 16 - year - old daughter were at a drive - in movie.

SHOORES AND OTHERS of the city's race leaders quieted the crowd that gathered at the scene of the blast as news of it swept the colored community. Police said some 1,000 angry persons gathered and reported some rock throwing.

The violence came swiftly on the heels of board of education announcement Monday that the city's 12th-grade classes would integrate in September. It was the most serious incident since mass demonstrations ended last spring.

The Alabama Christian Movement for Human Rights, an integration group based here, issued a statement calling on all citizens to keep the peace "which was rought by faith" and to retrain from further violence.

THE $50,000 REWARD was posted by the City Council for information about the Shore's bombing, the May 11 blast at the home the Rev. A. D. King, a recent motel explosion, and the tear-gas bomb incident at a department store last week.

Estimates of damage done by Tuesday's explosion were set at $8,000. The Shores' $35,000 - place home was located on "Dynamite Hill," so - called because of other bombings in the area over the years.

Shores has legal counsel for James A. Hood, the University of Alabama's first male student, who was admitted June 10 with federal

(Continued on Page 2)

Dr. Hawkins wins long, bitter fight

CHARLOTTE, N. C. — A hospital here and one at Fayetteville have dropped racial bars. The decision here however came only after federal investigators said they found valid, charges brought by local medic Dr. R. A. Hawkins, in a long and sometimes bitter fight.

Officials of the hospital here, Charlotte Memorial, Thursday announced the policy change after being closed for four hours to the four investigators from the

U. S. Public Health Service.

The change was confirmed by one of the investigators, William Burleigh, special assistant to the Health Services hospital facilities division.

He said "they have agreed to apply the same principles of admission to all."

THE CAPE FEAR Valley Hospital was the Fayetteville facility which removed racial

(Continued on Page 2)

What They Say

"The black American, 100 years after the Emancipation Proclamation, is alarmed and angry when he

72nd Year, No. 6 — Contents of Newspaper Copyrighted 1963 by AFRO - AMERICAN Co. — BALTIMORE, MD., AUGUST 31, 1963 — NATIONAL EDITION — 28 PAGES — ★★★★★★★ — 15 CE

'Demonstrate and leaving the cleaning and cooking to us'

NEW YORK — Scores of New York housewives will probably have to do some extra cleaning and cooking Aug. 28, according to Marion O. Jones, executive director of the National Domestic and Migrant Workers Association.

Jones said the association has chartered five buses to transport domestic workers in the New York metropolitan area to join the March on Washington.

"Many of these workers, some of whom have been viciously exploited and others who have been forced to seek domestic work because other avenues of employment have not been open to them, want to lend their voices to this historic protest for freedom and jobs," Jones stated.

Farmer in jail, misses big march

DONALDSONVILLE, La.—Unless Louisiana justice is more liberal than it has formerly shown itself to be, one of the sponsors of Wednesday's "March on Washington for Jobs and Freedom" will not be present.

He is James Farmer, national director of CORE, who is among the 224 civil rights fighters arrested last week for demonstrating in Plaquemine.

The arrests accompanied a series of marches and demonstrations in protest of Mayor Charles B. Schnebelen's refusal to negotiate jim-crow in public places, employment and political representation.

THE FIRST arrests were made Aug. 19 when Mr. Farmer and 16 others were arrested on a march to City Hall from Plymouth R Baptist Church. Others vol-

(Continued on page 11)

We Shall Overcome!

200,000 Voices Will Be Heard!

By ARTHUR HATFIELD

WASHINGTON

More than 200,000 civil rights crusaders can be credited with creating a turning point in American history.

As participants in the great March on Washington for Jobs and Freedom, they have given birth to a new national conscience which is demanding civil rights and equal employment for all Americans without delay.

There is no way of telling now how much the Aug. 28 march will stimulate the actions of Congress in considering President Kennedy's civil rights program.

THERE IS no question, however, that the imprint left by multitudes of civil rights marchers will linger on many a legislator's mind.

The march was the largest group petition for rights ever made in America.

Organized on a nonpolitical, nonpartisan basis, it accepted funds from no political party.

MOST CIVIL rights crusaders believe that the demonstration will contribute greatly to keeping the civil rights issue before the Congress and the American public until effective legislation is passed.

High on the list of march objectives, of course, is the matter of awakening reactionary Republicans and Southern Democrats to the point of acting favorably on civil rights.

Congressmen in this group include some of the most important figures in Washington. They hold down top party positions and are chairmen of influential legislative committees.

AS OF now, the forecast for Congressional debate on the rights issue extends to the start of 1964.

President Kennedy has stated that he knows of no reason why legislation should not be passed in 1963.

This is one goal of the march, to dramatize the need

for enactment of national civil rights and fair employment laws — without compromise or filibuster — now.

ADVANCED PLANNING for the massive demonstration stressed the importance of the marchers being orderly, even solemn in spirit. March leaders ruled out demonstrating at the Capitol and White House. Instead, it was decided to hold a mammoth march from Washington Monument to Lincoln Memorial.

The plan included a call on the White House by selected rights leaders and a report of the meeting with the President and Congressional leaders made at the Lincoln Memorial rally.

ALL OF THE Senators and Representatives were invited to listen to the 10 leaders of the march, speaking for three minutes each on the demands for equality in jobs and civil rights.

March headquarters invited participation by civil rights fighters who have faced tear gas, water hoses, electric jolts, police dogs and arrests.

Seats of honor were assigned for Mrs. Medgar Evers, wife of the Mississippi leader who was killed from ambush; Mrs. Gloria Richardson, leader of the Cambridge, Md., drive; Mrs.

(Continued on Page 2)

Catholic bishops take stand

WASHINGTON — (NNPA) —On the eve of the greatest civil rights march in history, the Catholic bishops of the United States have reaffirmed that racial discrimination "cannot be reconciled with the truth that God has created all men with equal rights and equal dignity."

In a joint pastoral letter released by the National Catholic Welfare Conference and read at churches throughout the country on Aug. 25, the bishops "proclaimed with one voice" their "moral judgment on racial discrimination and segregation."

They called on 45 million members of the Catholic faith in the United States to "remove obstacles that impede the rights and opportunities of our Negro brethren."

A partial text of the letter follows:

"We reaffirm that segregation implies that people of one race are not fit to associate with another by sole fact of race and regardless of individual qualities...We

(Continued on Page 2)

It was day of triumph for Rando

WASHINGTON—August 28 was March Washington day.

But to many who followed the history civil rights movement the last several deca... was A. Philip Randolph

It was Randolph, a energetic and tireless ...paigner who more tha... other one person was ... sible for the mem... event of August 28, 1963.

Randolph, who is pre... of the International B... hood of Sleeping Car P... and only colored memb... the AFL-CIO executive cil, is the originator ... idea of a March on Was ...ton to advance civil rig...

SOME CLAIM that ...dolph's march idea, fir... vanced in 1941 during early days of World Wa... actually originated with ...cob A. Coxey, who le... march on Washington years ago demanding f... for unemployed wo... during the depression 1893.

His straggley procession 450 follower... was arre... for trespassing on the C... tol grounds and routed.

The episode won for ...leader the derisive titl... "General" and his follo... "Coxey's Army."

When that happened

(Continued on page

March leaders ha... to call on military to solve 1 problem

WASHINGTON (ANP) Army quartermaster ...sonnel and public hea... officials were called in ...help Aug. 28 March le... ers determine how to ...pose of between 35 and ...tons of human waste ... have and where to pla... comfort stations.

The amount of plann... that went into this o... problem of the massi... civil rights demonstrat... illustrates the compl... complications of provid... accommodations for tho... ands of away - from - ho... persons.

Arrival of the estim... of human waste and t... number of stations nee... ed to handle the proble... was computed by t... Army which had to b...

SKATING FOR FREEDOM — Ledger Smith, 27, Chicago, Ill., wheels down Michigan Ave. on an old pair of roller skates. Smith was determined to skate 698 miles to Washington in time for the civil rights rally. He carried two extra sets of wheels for his lace-up shoe skates and a "Freedom" banner pinned to his shirt.

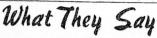

Husband denies 2 torch murders

MARCH on WASHIN...

T HE NEXT DAY'S NEWSPAPERS praised the "orderly" demonstration. *The New York Times* called it "the most impressive assembly for a redress of grievances in America's history."

The Washington Post rhapsodized about the diversity: "Every kind and class of American was there. The humble and the great...All were present. America sent to that great meeting in her Capital the representatives of every one of her manifold aspects and estates.

"It was part picnic, part prayer meeting, part political rally, combining the best and most moving features of each. It was a happy crowd, much more gay than grim, full of warmth and good feeling and friendliness, instinct with faith and high hope, united in a sense of brotherhood and common humanity."

The March ended for Bayard Rustin, the organizing genius behind the event, when he checked the Monument grounds in early evening to "finally make sure we had not left one piece of paper, not a cup, anything. We had a five-hundred-man clean-up squad. I went back to the hotel and said to Mr. Randolph: 'Chief, I want you to see that there is not a piece of paper or any sort of filth or anything left here.' Mr. Randolph went to thank me and tears began to come down his cheeks." Randolph later said: "It was the most glorious day of my life."

Ralph Abernathy, who co-founded the Southern Christian Leadership Conference with Dr. King, also returned to the grounds that evening. "There was nothing but the wind blowing across the reflection pool. We were so proud that no violence had taken place that day. We were so pleased. This beautiful scene of the wind dancing on the sands of the Lincoln Memorial. I will never forget it."

THE SWEET WIND FROM THE
March on Washington reached triumphant gale force in 1964 with the
passage of the Civil Rights Act followed by the Voting Rights Act of 1965,
and finally the 2008 election of Barack Obama as the first African American President of the United States. Yet with these gains came immense loss and lament. Hope had been caged too long for the brutes of anger and despair not to break loose and go on a rampage, leaving an ugly wreck of riot-torn corridors in burnt-out cities across the nation. John F. Kennedy and Martin Luther King, Jr., the gentle giants of nonviolence, had been assassinated like Abraham Lincoln, but in the wake of blood and bullets they left behind a better America, still trying "to hew out of the mountain of despair a stone of hope."

(opposite) **President Lyndon Baines Johnson (1908–1973), a few days after the assassination of John F. Kennedy, addressed the nation on the subject of race:**

No memorial oration or eulogy could more eloquently honor President Kennedy's memory than the earliest possible passage of the civil rights bill for which he fought so long. We have talked for one hundred years or more. It is time now to write the next chapter, and to write it in the books of law.

President Johnson signed into law the Civil Rights Act of 1964 and the Voting Rights Act of 1965.

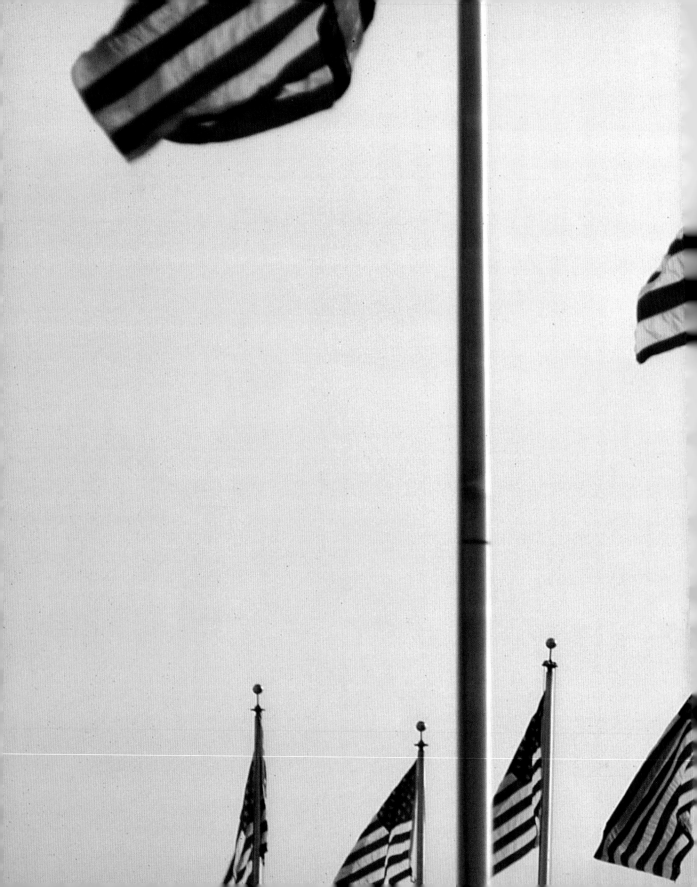

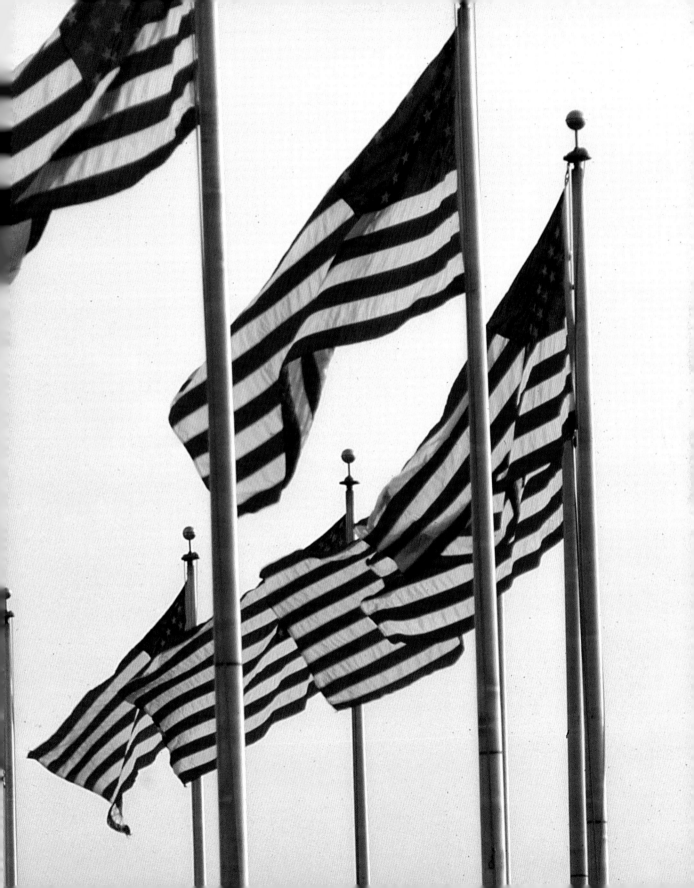

S TANLEY TRETICK (1921–1999), one of the preeminent photojournalists of his era, took the photographs in this book, which are published for the first time.

Born in Baltimore, reared in Washington, D.C., and trained as a photographer in the Marine Corps during World War II, Tretick's first civilian job was for United Press International, where he covered Congress. He later covered John F. Kennedy's 1960 presidential campaign. On the road during that time, the candidate and the photographer developed a close working relationship, and when Kennedy went to the White House, Tretick went to *Look*, the premier photojournalism magazine of its day. His assignment was to cover President Kennedy and his family, and with his special access to the Kennedys, Tretick captured iconic photographs of Camelot, including the famous image of three-year-old John F. Kennedy, Jr., playing under his father's desk in the Oval Office.

In 1963, Tretick was one of the photographers issued special credentials to cover the March on Washington, but his photos, shown in this book for the first time, were not published because of the bimonthly magazine's long lead time.

Born poor himself, the photographer seemed to bring a special empathy and understanding to his coverage of those who marched for freedom and jobs. Three years after the March he followed the Reverend Dr. Martin Luther King, Jr., to East Garfield, then one of Chicago's poorest black districts. King, known as "Moses, Jr." to residents there, was trying to organize a house-by-house, block-by-block union to end slums. He wanted to mold a coalition of blacks and whites from the activist community of unions and churches to make "demands greater than Chicago is willing to give so that the federal government will be forced to act." As always, Dr. King sought to achieve his goal in a peaceful, nonviolent way.

As with John F. Kennedy, Tretick recognized greatness in Martin Luther King, Jr., after covering the 1963 March on Washington, depicted here with all its humanity. The images in this book capture the civil rights movement at its crest, when the country—blacks and whites, Christians, Protestants, Jews, and Muslims—came together to demonstrate their commitment to equal justice for all.

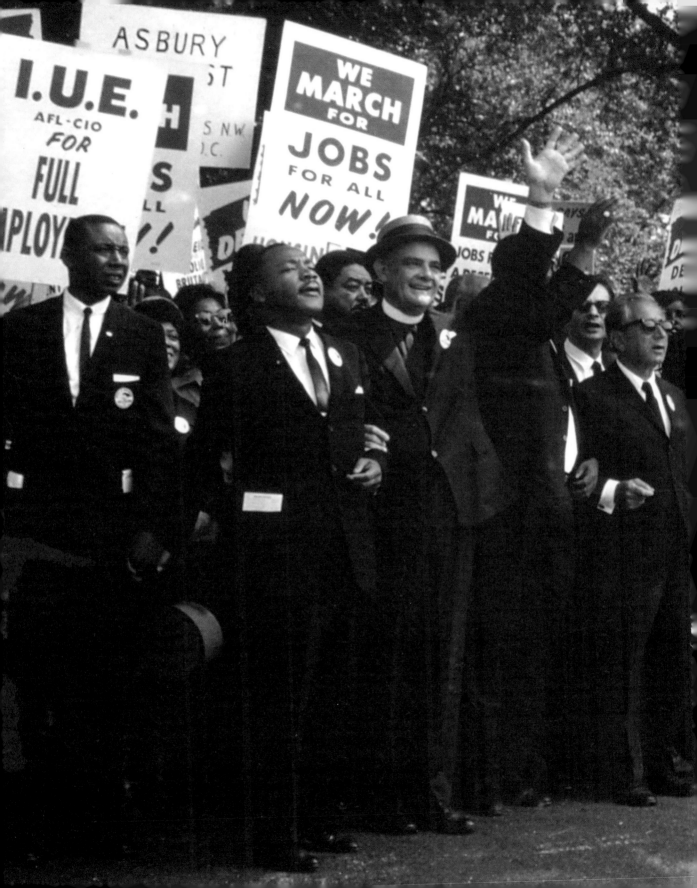